Camera **preparation**

While attaching a lens to the Nikon F80 / N80 and loading film and batteries may seem very basic stuff, being able to do so under pressure or in extreme conditions may be the difference between getting the shot or not.

All photographers can recount occasions when their haste to load a new film has limited the speed in which they've achieved it. The result is often the photographers equivalent to the fisherman's 'one that got away'. Mastering these techniques so that they become second nature will greatly reduce the likelihood of lost photo opportunities when the subject has a mind and a will of its own.

Mounting a lens

1) Having removed the rear lens cap and the camera body cap (if attached) align the mounting index marks on the camera body and the lens (two solid black dots) and gently fit the lens into the bayonet mount. With the lens firmly in place, and making sure not to press the lens release button, twist the lens anti-clockwise until it locks into place. You should hear a solid click as the lock engages.

⚠ Common errors

If the top LCD panel shows a '- -' mark next to the aperture indicator then the lens has not been attached properly. It is likely that the lens has not been locked in place completely.

Removing a lens

1) To remove a lens from the lens mount, press down and hold the lens release button and, holding the lens by the barrel, turn it clockwise.

2) Be sure to replace the rear lens cap before storing the removed lens to protect it from dust and scratching.

Tip

When changing lenses in bright conditions, shield the camera from direct, strong light sources so as to lessen the possibility of light penetrating the shutter curtain and adversely affecting the film.

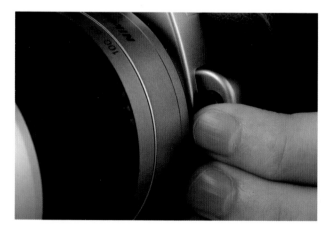

Installing batteries

1) To install batteries, open the battery chamber by sliding the catch and flipping the chamber door open.

2) The camera requires two CR 123A batteries. The underside of the chamber door features two contacts. The long oblong-shaped contact is positive (+) and the small round nipple contact is negative (-). A label in the chamber also illustrates the correct position of the batteries.

3) Once the batteries are installed, close the battery chamber.

> **Note**
> When installing or replacing batteries always read any directions given by the battery manufacturer.

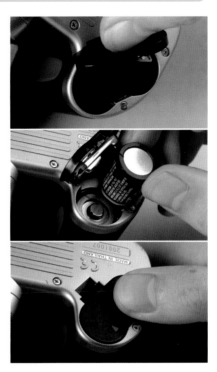

Checking battery power levels

To check on the power level of installed batteries turn the camera on and check the battery indicator in the top LCD panel.

 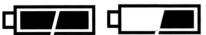

Sufficient battery power for normal operation.

Batteries are nearing exhaustion and will soon need replacing.

Blinking: Batteries are almost exhausted and should be replaced.

If no indication appears, the batteries are completely exhausted and need replacing, or are installed improperly.

Loading film

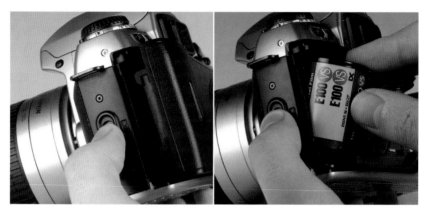

1) To load a film open the camera back, sliding the door release downwards until the back flips open.

2) Insert the film cartridge into the film holder.

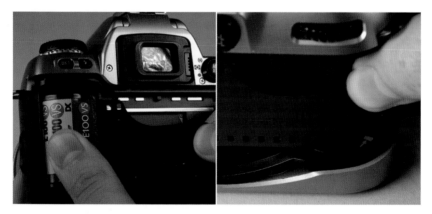

3) Hold the film cartridge in place with your left thumb, and take hold of the film leader with your right thumb and index finger.

4) Pull the film leader across until it reaches the red marking by the film take-up spool.

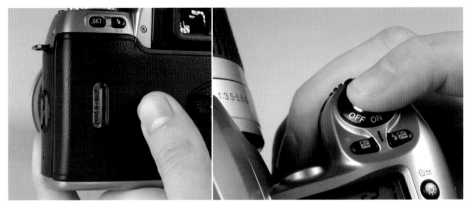

5) Then, ensuring that the film lies flat, close the camera back until it locks firmly into place.

6) With the power on, press the shutter release to engage the film advance function.

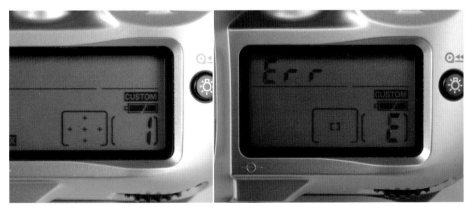

7) The film will automatically wind forward to the first frame and the number **'1'** will appear in the frame counter in the top LCD panel and in the viewfinder LCD panel.

8) The error message **'Err'** in the top LCD panel indicates that the film has been loaded incorrectly. Open the camera back and repeat the loading process above.

⚠ Common errors

If, after loading the film, the error message **'Err'** blinks in the top LCD panel and the frame counter remains reading **'E'** (Empty), then the film has been loaded incorrectly. The film leader being pulled too short a distance across the camera back and not aligning with the red indicator usually causes this. To avoid this problem, make sure a good portion of the film has reached the red indicator before closing the back.

Notes

Avoid making any contact between you and the electronic sensors in the camera.

Avoid making any contact with the shutter curtain either with your hand or the film leader. The curtain is sensitive and easily damaged.

Avoid making contact with the back pressure plate on the inside of the film chamber door.

To avoid accidental fogging of the film, always load film out of direct sunlight or other powerful light source.

Setting film speed and DX coding

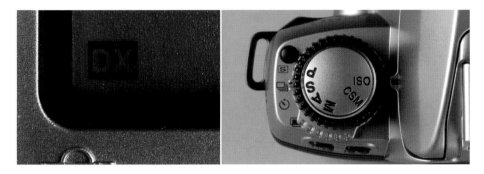

1) Film speed (ISO rating) can be input manually (ISO 6–6400) or read automatically using the DX coding on the film canister (ISO 25–5000). When set to automatic, a DX symbol appears in the top LCD panel.

2) Each time a new film is installed the camera defaults to DX. You can also select DX coding via the exposure mode dial. To select DX coding, set the exposure mode dial to ISO and rotate the main-command dial until **'DX'** appears in the top LCD panel.

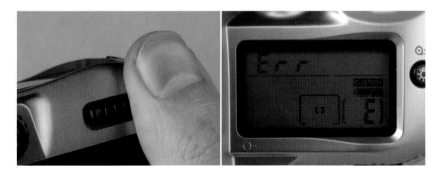

3) The camera will then operate at the film's pre-set ISO rating – within an available range of ISO 25–5000. For films rated outside of this range, manual setting of film speed using the main-command dial is necessary.

4) If attempting to load non-DX coded film or DX coded film outside the cameras range an **'Err'** error message will blink in the top LCD screen and the shutter release will deactivate.

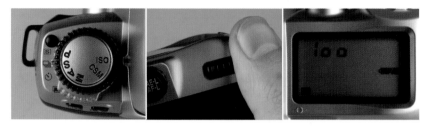

5) To select the film speed manually, set the exposure mode dial to 'ISO' and rotate the main-command dial until your chosen speed appears in the top LCD panel. Film can be rated between ISO 6–6400 in 1/3 stops.

The camera will not operate while the exposure mode dial is set to 'ISO', set the dial to the desired exposure mode of M, A, S or P before shooting.

In custom function #2, the film speed setting can be set to stay in manual when a new film is loaded.

Tip
Manually rating film is useful when pushing film for additional speed or pulling film to reduce film speed. Be careful when pushing or pulling film as different films react in different ways. Always read the manufacturer's advice.

Note
When the camera is set to manual film speed selection the manually selected ISO rating will override any DX coding on the film canister.

⚠ Common errors

If you have re-rated a film's speed (pushed or pulled) always remember to mark the film canister as soon as you remove it from the camera. Otherwise, once it's mixed up with other exposed film it'll be nigh on impossible to remember which film is which.

Rewinding film

1) When the film reaches the end of the roll the camera will automatically rewind it. Rewinding is illustrated in the LCD panel by a graphic along with a countdown of the frame counter. Film is completely rewound when the frame counter shows a blinking **'E'**.

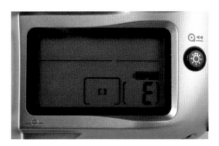

Mid-roll rewind

1) Mid-roll rewind is also possible. To rewind the film, press the two rewind buttons simultaneously for approximately one second. The film will automatically begin to rewind. To indicate rewind a graphic representation will appear in the LCD panel and the frame counter will count backwards. Film is completely rewound when the frame counter shows a blinking **'E'**.

 Automatic rewind of a 36-exposure film under normal conditions will take around 15 seconds.

⚠ Common errors

If automatic film rewind fails to start or stops part way into the process then it is likely that battery power is insufficient to complete the operation. Check there is adequate battery power before beginning automatic film rewind and this problem should not occur. If it does, turn off the power and replace the batteries and rewind film again.

Basic camera functions

Now that your camera is fully loaded and ready to go, the next step is to consider some of the rudimentary functions and controls to get you taking pictures with the F80 / N80.

In its simplest form, the F80 / N80 is an easy camera to operate and provides you with most of the information you need to capture great shots. In this section of the book we explore how to get the most from your F80 / N80 as a basic camera, concentrating on photographic technique and putting you in control of the camera, rather than the other way around.

⚠ Common errors

If, after turning the camera on, the LCD panels remain blank then battery power is exhausted. To avoid this happening when you can least afford it, regularly check the battery power level and replace batteries before they are fully exhausted.

Powering on

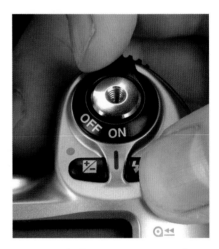

1) To switch the camera on, turn the power switch clockwise until the index mark points to **'ON'**.

Getting started

1) In its default setting, with no functions applied, the top LCD panel will display your current focus area (single area AF or dynamic AF), frame number (or 'E' if no film is loaded) and battery level.

2) Depressing the shutter release button half way will add the current shutter speed and lens aperture.

3) In the viewfinder LCD you will see the current metering mode (matrix ▟▀, centre-weighted ⊙ or spot ⊡), shutter speed and lens aperture settings, the electronic analogue exposure display and the frame counter. The focus area and focus indicator is also displayed.

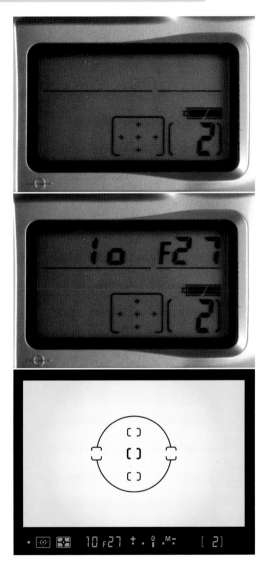

Handling the F80 / N80

The F80 / N80 is a well thought-out camera, with a fairly light weight of 515g and compact size, yet still feeling robust and solid. All the main controls are easily to hand and in either horizontal or vertical shooting format your hand securely contours the front grip.

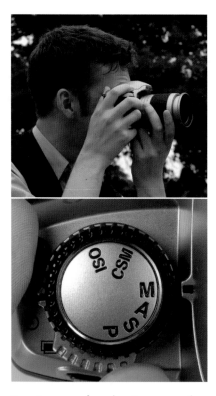

To set your preferred option, press the film mode selector lock and simultaneously rotate the film mode advance selector dial.

The viewfinder displays the five areas of focus and the centre-weighted metering reference circle. The viewfinder displays 92% of the image area so bear in mind that what you see is slightly less than what you get on film.

Before using the camera set the film advance mode. On the F80 / N80 there are two options. Single advances the film one frame for each press of the shutter release button. In continuous mode the film advances at 2.5 frames per second, while the shutter release is pressed.

The film advance dial also provides a self-timer facility with single frame advance. In its standard setting the self-timer delays the release of the shutter by ten seconds. The length of this delay can be altered using the custom function control (see page 78).

Also situated here is the multiple exposure setting, which lets you take two or more images on the same frame of film.

⚠ Common errors

Forgetting to change the self-timer mode back to a normal film advance mode will leave you guessing why the shutter isn't firing when you press the shutter release button. Remember to change back to a normal film advance mode once you have finished using the self-timer.

Focusing with the F80 / N80

The development of autofocus in camera technology was one of the great advances in photography. No longer having to rely on manual focusing, exponents of fast-action photography of subjects such as motor sports and wildlife began to create images that, in technical terms, were far in advance of popular photography.

Focusing with Nikon

It is fair to say that, in the early days, Nikon was not the leader in the autofocus field, its technology lagging behind that of its main rival, Canon. Constant development over many years, however, has seen Nikon catching up and the autofocus system operational in the F80 / N80 now competes with the best of them.

When used with AF Nikkor lenses autofocus activates when the focus mode selector is set to 'S' (single servo) or 'C' (continuous servo) and when the shutter release button is depressed half way. The F80 / N80 autofocus system operates across five separate detection sensors and with a choice of single or dynamic area modes. Autofocus can be performed in either single servo or continuous servo modes. Focus tracking automatically activates when the subject moves just as long as the focus has not locked-on.

For the traditionalists, or when non-AF Nikkor lenses are being used, and for those occasions when autofocus is more trouble than it's worth, the F80 / N80 can operate in manual focus mode. Here technology can still lend a hand. The camera has an electronic focus indicator that activates a small LED in the viewfinder that indicates whether the subject is in focus.

AF assist illuminator

Notes

For autofocus to operate successfully the lens in use must have a maximum aperture of no more than f/5.6. While this covers the majority of the Nikkor lens range it excludes the use of a 1.4x teleconverter with lenses where the maximum aperture is slower than f/4, and with a 2x teleconverter with lenses where the maximum aperture is slower than f/2.8.

Tip

Autofocus will fail to operate when lenses are used in conjunction with linear polarizing filters. Use a circular polarizing filter instead.

If the ambient light is too low for the AF system to function correctly, the AF assist illuminator automatically lights up the subject, even in total darkness. The feature only works in AF-S mode when the centre focus area is selected and or when closest subject priority dynamic AF mode is activated.

Note

The AF assist illuminator is compatible with 24–200mm lenses with some exceptions.

Selecting the focus area

Because the main subject of the photograph is often off-centre the F80 / N80 provides five separate focus area sensors. These are positioned at top, bottom, left, right, as well as centre. So, when composing a picture using the rule of thirds, for example, the camera allows you to select a sensor that more closely matches the position of the main subject within the frame. This makes autofocusing a far easier task, requiring less camera movement and re-framing.

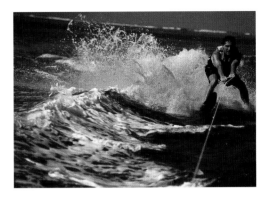

To select the required focus area

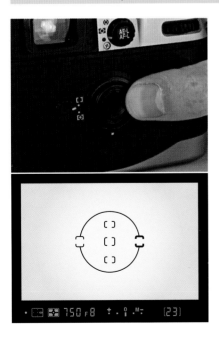

1) Press the corresponding arrow on the focus area selector.

2) The selected focus area will be highlighted in bold in the viewfinder and will appear in the relevant position on the top LCD panel.

Single area and dynamic focus modes

To suit different shooting conditions and subjects the F80 / N80 provides two different AF area modes. In single area AF mode you designate the focus area and your choice will remain unchanged even if the subject moves. This is particularly suitable for static subjects such as landscapes, architecture, still life and portraits.

Notes
Once the primary focus area sensor is selected the active focus area indicator will not change even if the sensor is shifted.

In continuous servo AF mode depressing the 'AE-L/AF-L' button will lock focus.

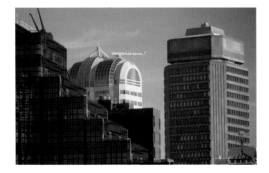

Below: Autofocus on the F80 / N80 really gets exciting with dynamic AF mode. Using dynamic AF you first designate a primary focus sensor. The lens focuses on the subject covered by that sensor. If, however, the subject moves the F80 / N80 will automatically follow that movement, shifting to the next sensor that detects the subject, progressively shifting sensors as the subject continues to move. With dynamic AF the subject, once in focus, will remain in focus.

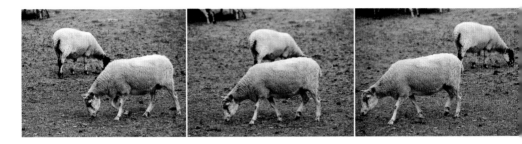

Above: A supplementary mode to this is dynamic AF with closest subject priority. This automatically maintains focus on the subject closest to any of the five focus areas and focus is locked. In continuous focus, if the subject moves the five sensors will track the subject as in normal dynamic AF mode.

Selecting AF mode

1) To select the AF area mode, rotate the AF area mode selector switch. In dynamic AF area mode a cross (+) appears in all five of the AF sensors indicated on the top LCD screen.

2) In single area AF mode no crosses appear on the top LCD screen. Dynamic AF with closest subject priority is selected in the custom menu (see page 76).

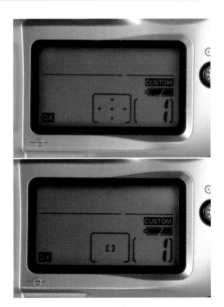

Focus priority

The F80 / N80 allows you to decide whether priority is given to correct focus or shutter release. As standard, in single servo AF mode priority is given to correct focus and you can fire the shutter only once the camera detects correct focus in one of the five focusing areas. Once correct focus has been detected focus will remain locked so long as the shutter release button is slightly depressed, or the 'AE-L/AF-L' button is fully depressed. In this case, if the camera-to-subject distance changes you will need to refocus.

In continuous servo AF mode priority is given to shutter release and the shutter can be fired whether or not the subject is in focus. When AF is activated the lens will continue to focus automatically as the camera-to-subject distance changes, until AF is deactivated by releasing pressure on the shutter release button.

Confirming correct focus status

When correct focus is detected by the F80 / N80 the AF motors will stop and the lens will become still. When the subject is in focus a green circle appears in the LED panel of the viewfinder.

AF-Lock

In either single servo AF or continuous servo AF modes autofocus will lock when the 'AE-L/AF-L' button is depressed. (In single servo AF mode with focus priority, pressing the 'AE-L/AF-L' button replicates keeping the shutter release button depressed.) Locking focus with the 'AE-L/AF-L' button will lock the exposure at the same time.

This function can be useful when the main subject falls outside of the focus area sensors as correct focus can be achieved and locked, and the picture recomposed.

⚠ Common errors

When using AF to focus on off-centre subjects remember to lock the focus before recomposing. Otherwise, focus will reactivate as soon as you move the camera meaning that your subject will appear out of focus.

Note
The 'AE-L/AF-L' button can be programmed to lock focus only, via custom function #11 (see page 77).

Manual focus

The F80 / N80 can be focused manually when autofocus operation is either impossible or inappropriate. For example, when in use with non-AF lenses or when the subject is defined less clearly.

To use the camera in manual focus mode and without lenses that have an 'A/M' (Auto/Manual) switch, set the focus mode selector switch to the **'M'** position. With lenses that have the A/M switch

facility (typically AF-S and AF-I lenses) set the lens switch to **'M'** or **'M/A'**. In this instance it is unnecessary to set the focus mode selector switch on the camera to **'M'**. Determining correct focus in manual focus mode can be achieved via the electronic rangefinder (suitable with most Nikon lenses with a maximum aperture of f/5.6 or faster, including AF lenses used in manual mode) or via the focusing screen.

To use the electronic rangefinder in manual focus mode

1) First select one of the five focus areas and position the subject within the corresponding sensor. Lightly press the shutter release button and focus using the lens-focusing ring. When the subject is in focus a green circle appears in the viewfinder LCD.

2) To use the clear matte-focusing screen found on the F80 / N80, look through the viewfinder and rotate the lens-focusing ring until the image appears sharp.

Note
Never rotate the focusing ring on the lens with the camera and lens set to autofocus operation, as this will cause damage.

Depth of field preview

When a lens is attached to the F80 / N80 the camera automatically opens the lens aperture to its maximum setting. The reason for this is to ensure a bright screen on which to compose the image and focus the subject. However, this makes it impossible for you to see the available depth of field when shooting at apertures slower than the maximum. By stopping the lens down to the working aperture it is possible to define the exact depth of field through the viewfinder and so take out much of the guesswork involved through manual calculation.

Note
While the depth of field preview function can be activated in all exposure modes, it only really works effectively in aperture-priority AE and manual exposure modes.

To activate depth of field preview

First compose the picture in the viewfinder and set the required exposure. Then, press the depth of field preview button. You'll hear a small click followed by the focusing screen darkening. How much darker the focusing screen becomes will depend on the selected lens aperture - the smaller the aperture the darker the screen becomes as less light is allowed to pass through to the focusing

screen. And, of course, if the selected aperture is the maximum lens aperture then no change in screen brightness will occur.

Tip

While the depth of field preview function can be activated in all exposure modes, it is most effective in aperture-priority-auto and manual exposure modes.

Notes

During preview the lens aperture cannot be adjusted and autofocus will not operate.

If metering through the lens during preview avoid using the spot meter (⊡) function.

TTL metering is not possible if the lens has a meter-coupler, as full-aperture metering is required.

Measuring depth of field

1) To ascertain depth of field at any given aperture, through the viewfinder look to see which areas of the image space appear in focus. Those areas that appear sharp in the viewfinder will also appear sharp on the film.

Correct exposure

Nikon's autofocus system may have lagged behind that of it's main rival for some time, its metering system was – and is still – second to none.

When Nikon introduced the F5, followed by the F100 an unparalleled level of information was used to calculate correct exposure through the lens (TTL). For the first time in any camera the F5 combined data on scene brightness, contrast, colour and, when used in conjunction with Nikon AF-D lenses, distance to subject information in order to calculate correct exposure. Much of this system has been inherited by the F80 / N80.

But there will still always be cases when circumstances dictate a greater level of manual control or when exposure compensation must be applied. Remember, you control the camera, the camera doesn't control you. Any information the camera gives is there to help the photographer make a technical or creative decision.

The F80 / N80 exposure system

The F80 / N80 has three types of metering system – 3D matrix ▓▓, centre-weighted ▣ and spot ▣, and four types of exposure mode - programmed-auto **(P)**, shutter-priority-auto **(S)**, aperture-priority-auto **(A)** and manual **(M)**.

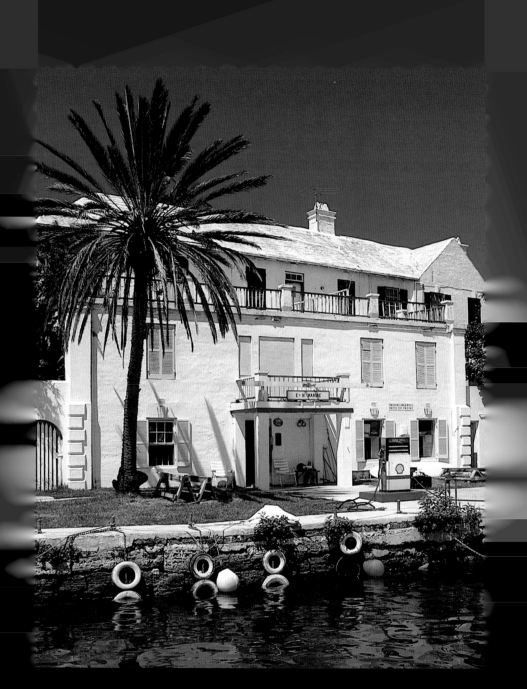

HAMILTON, BERMUDA
The hardest subjects to meter for are bright subjects (like the house) and highly reflective subjects like the water. Both can fool even sophisticated meters.

3D matrix metering

This exposure system is adapted from that of the Nikon F5 and F100. In calculating the correct exposure the system first measures a scene's overall brightness and contrast using a ten-segment 3D matrix sensor. It then applies distance information, provided by Nikon AF-D lenses, and compositional information, provided by the camera's autofocus system. This combined data is then analyszed against an in-camera database of 30,000 actual photographic scenes to provide the final exposure calculation. Though this system is not completely fool-proof, it does provide accurate readings in most lighting situations, whatever the complexity. A scene like this one taken in Montego Bay, Jamaica, with lots of different levels, is grist to the mill for the F80 / N80's 3D matrix metering.

Note
Matrix metering can only be used with D-type AF Nikkor lenses or later lens models.

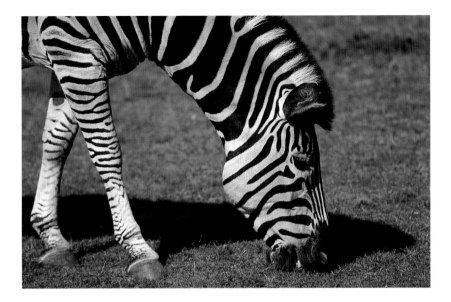

Centre-weighted metering

This is the classic form of auto exposure metering, although nowadays it is the least used. Centre-weighted metering calculates an averaged light reading based on 18% reflectance. The F80 / N80 concentrates 75% of the meter's sensitivity in the 12mm-diameter circle seen through the viewfinder and 25% outside this area. Typically, centre-weighted metering is used in portrait photography.

The image of a zebra above is an example of an instance in which using spot metering would be inappropriate, because of the contrast levels within the central subject. Yet using 3D matrix metering would meter for too wide an area. The use of centre-weighted metering allows the subject to be correctly exposed while still accommodating the contrast of the black and white of the zebra.

Note
Centre-weighted metering does not completely disregard the edges of the frame and so should be used with care for scenes with more than a third of the frame of sky.

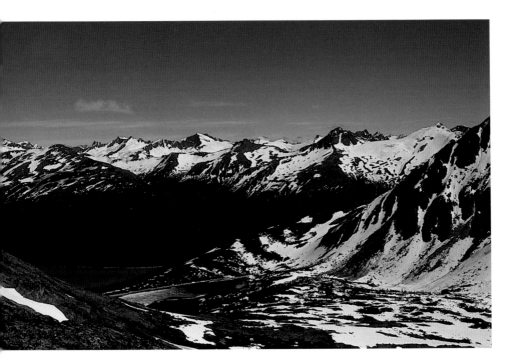

Spot metering

Spot metering provides precise metering of a very small area of the picture space and gives you the greatest level of control over the exposure calculation. With the F80 / N80 the area of sensitivity is concentrated within a 4mm diameter area that corresponds directly to the selected focus area, covering approximately 1% of the picture space. This is a very useful function when photographing landscapes. This Alaskan scene shows how spot metering can be used to prevent the highly reflective snow on the mountains from overexposing.

Note

If you are using spot metering for a tricky metering situation, always remember to switch back to your default metering setting after taking the picture. Spot metering is not appropriate for all scenes.

Selecting TTL metering mode

1) To select a metering system, rotate the metering system selector until the corresponding symbol aligns with the white index mark.

The selected metering system symbol also appears in the viewfinder.

Note
When using a non-CPU lens, or accessories such as bellows or manual extension rings the metering system automatically switches to centre-weighted metering.

Deciding on the ideal exposure mode

Which exposure mode you select will depend on how much control you want to maintain over lens aperture and shutter speed selection, and on whether lens aperture or shutter speed is more pertinent to your artistic interpretation of the subject. You will probably find that different subjects may require different exposure modes. The F80 / N80 provides four exposure modes giving you complete flexibility in controlling exposure.

To select exposure mode

1) Simply turn the exposure mode dial until the relevant letter aligns with the white index mark: **P** for programmed-auto, **A** for aperture-priority-auto, **S** for shutter-priority-auto and **M** for manual.

Programmed-auto exposure mode (P)

In programmed-auto exposure mode the camera automatically selects both the shutter speed and the lens aperture. You can alter the camera-selected combination, while maintaining consistent exposure, by using the Flexible Program function. For example, if the camera has selected an exposure of 1/125sec at f/8 and you determine a faster shutter speed is required, you can use the Flexible Program function to shift the shutter speed/lens aperture combination to, say, 1/250sec at f/5.6.

Note
Programmed-auto exposure mode, in combination with 3D colour matrix metering, is the simplest way of controlling exposure with the F80 / N80. However, this also places the onus of decision-making on the camera and if, like me, you prefer to take a more active approach to exposure control, then the following three modes will be more appropriate to getting the most from your photography.

To select the Flexible Program function

1) First make sure that you have selected programmed-auto exposure mode **(P)** on the exposure mode dial. Turn the main-command dial. A star will appear above the letter P.

2) After you have selected the Flexible Program function turn the main-command dial to shift the lens aperture/shutter speed combination until your desired setting is shown.

Aperture-priority-auto exposure mode (A)

In aperture-priority-auto exposure mode you select the required lens aperture and the camera sets the appropriate shutter speed depending on the meter reading. This gives you control over the depth of field and is most useful where foreground to background sharpness is important, such as in landscape photography.

Shutter-priority-auto exposure mode (S)

Shutter-priority-auto exposure mode allows you to select the required shutter speed while the camera sets the appropriate lens aperture depending on the meter reading. This mode is often used by photographers of fast-action subjects, such as motor sports and wildlife. The ability to determine the shutter speed gives the photographer creative control over freezing or blurring motion.

Manual exposure mode (M)

For the ultimate exposure control the F80 / N80 can be operated in fully manual mode, where you select both the aperture and the shutter speed. Most often this will be in conjunction with the meter reading from the camera but the manual system allows you to override any recommendations the meter makes. Manual exposure is often used when the photographer wants to achieve special creative effects.

Taking meter readings in auto exposure modes

⬛ Matrix metering

To take a meter reading in auto exposure modes using the matrix metering function, first compose the picture through the viewfinder. Lightly press the shutter release button to activate the meter. The camera will then select the relevant shutter speed and lens aperture combination in programmed-auto mode; the shutter speed in aperture-priority-auto mode; and the lens aperture in shutter-priority-auto mode.

⬚ Centre-weighted metering

To take a meter reading in auto exposure modes using the centre-weighted metering function, first centre the main subject inside the viewfinder so it fills the reference circle. Lightly press the shutter release button to activate the meter. The camera will then select the relevant shutter speed and lens aperture combination in programmed-auto mode; the shutter speed in aperture-priority-auto mode; and the lens aperture in shutter-priority-auto mode.

⬚ Spot metering

To take a meter reading in auto exposure modes with the spot metering function, place the active focus bracket over the area of the scene you want to take the reading from. Lightly press the shutter release button, this will activate the meter. The camera will then select the relevant shutter speed and lens aperture combination in programmed-auto mode; the shutter speed in aperture-priority-auto mode; and the lens aperture in shutter-priority-auto mode.

Manual exposure mode

In manual metering mode the F80 / N80 provides a barchart display in the bottom of the viewfinder as an aid to exposure. Each marking represents a 1/2 stop change in exposure setting, over a +/–3 stop range. When no markings appear and a '0' appears above the centre index mark, then correct exposure is indicated. The number of markings appearing along the bottom indicates the level of under- or overexposure.

Tip
If the marker constantly switches between two points it indicates that the level of light entering the lens is not constant. Whichever setting you choose, the final exposure difference will be largely indistinguishable to the naked eye.

When the exposure setting is more or less than two stops under- or overexposed, the bottom markers remain at the –3 or +3 positions, respectively. Altering the exposure settings will only cause the markers to change visibly once they have come within the +3 to –3 range.

To change the exposure, alter the lens aperture or shutter speed with the sub- or main-command dials respectively, until the correct exposure is indicated.

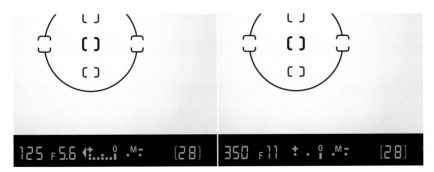

Taking meter readings in manual exposure mode

▚ Matrix metering

To take a meter reading in manual exposure mode using the matrix metering function, first compose the picture through the viewfinder. Lightly press the shutter release button to activate the meter. Using the analogue display as a guide, adjust either the shutter speed or lens aperture via the main- and/or sub-command dials until the electronic analogue exposure display indicates correct exposure.

⊙ Centre-weighted metering

To take a meter reading in manual exposure mode using the centre-weighted metering function, first centre the main subject inside the viewfinder so that it fills the reference circle. You should also be aware of the rest of the scene as the F80 / N80 still takes 25% of the reading from outside the reference circle. Lightly press the shutter release button to activate the meter. Using the analogue display as a guide, adjust either the shutter speed or lens aperture via the main- and/or sub-command dials until the electronic analogue exposure display indicates correct exposure.

⊡ Spot metering

To take a meter reading in manual exposure mode using the spot metering function, first place the active focus bracket over the area of the scene you want to take the reading from. Lightly press the shutter release button to activate the meter. Using the analogue display as a guide, adjust either the shutter speed or lens aperture via the main- and/or sub-command dials until the electronic analogue exposure display indicates correct exposure.

Exposing for off-centre subjects in centre-weighted metering mode and spot metering mode

In centre-weighted metering mode and spot metering mode, if the main subject is off-centre, or falls outside of the focus area brackets, position the subject in the viewfinder so it fills the reference circle or active focus bracket. Take a meter reading as described above.

If shooting in an auto exposure mode, lock the selected exposure settings using the 'AE-L/AF-L' button and recompose the scene as required. Still depressing the 'AE-L/AF-L' button, fire the shutter.

If shooting in manual exposure mode there is no need to lock the exposure settings. Once the correct exposure settings have been set recompose the scene as required and fire the shutter, as long as light levels do not change between the setting of the shutter speed and aperture and the moment of taking the picture.

Selecting lens aperture and shutter speed settings

Shutter speed is selected in shutter-priority-auto and manual exposure modes by slightly pressing the shutter release button and then turning the main-command dial. In its default setting, turning the main-command dial counter-clockwise will increase the shutter speed, turning it clockwise will decrease the shutter speed.

Lens aperture is selected in aperture-priority-auto and manual exposure modes by slightly pressing the shutter release button and then turning the sub-command dial. In its default setting, turning the sub-command dial counter-clockwise decreases the aperture, while turning it clockwise increases the aperture.

Notes

Programmed-auto and shutter-priority-auto exposure modes operate only with lenses that have a built-in CPU.

All adjustments of lens aperture or shutter speed are made in 1/3 stops.

For use with lenses that have no CPU, or with accessories such as bellows or manual extension rings the F80 / N80 should be operated in aperture-priority-auto or manual exposure modes. If programmed-auto or shutter-priority-auto exposure modes are selected the camera will automatically revert to aperture-priority-auto exposure mode. If 3D matrix metering is also selected, the camera will automatically switch to centre-weighted metering.

AE-Lock

Pressing the 'AE-L/AF-L' button will lock the current exposure setting in all auto exposure modes. This is particularly useful when taking an exposure reading of a subject in spot metering mode, where the subject will fall outside of the corresponding focus area sensor in the final composition.

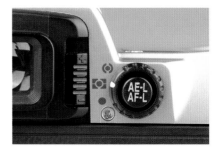

In this instance, place the selected focus bracket on the subject. Once the meter reading has been taken and the appropriate exposure settings made, press the 'AE-L/AF-L' button and recompose the picture as desired. The exposure settings will remain locked until you release the 'AE-L/AF-L' button.

Notes

The lens aperture in aperture-priority-auto, and the shutter speed in shutter-priority-auto can still be changed even when the 'AE-L/AF-L' button is depressed. In this instance the shutter speed or aperture, respectively, will automatically shift to adjust to your changes.

The metering system cannot be changed when the 'AE-L/AF-L' button is depressed.

The 'AE-L/AF-L' button can be programmed to lock exposure only via the custom function settings (see page 77).

Exposure compensation

Despite the sophistication of the F80 / N80's exposure system there are occasions when you will need to make adjustments to the exposure setting to gain the exposure you require. For example, when photographing subjects that are considerably darker than, or lighter than, mid-tone (18% grey). For subjects such as snow or dark buildings the indicated meter reading will almost certainly require some adjustment.

In any auto exposure mode this adjustment can be made by dialling in a level of exposure compensation between –3 to +3 stops in 1/2 stop increments. This causes the camera to adjust its exposure settings automatically to take account of your exposure calculations.

In aperture-priority-auto exposure mode the camera will shift the shutter speed by the required amount, while in shutter-priority-auto exposure mode it will shift the lens aperture. In programmed-auto exposure mode the camera will shift a combination of both the lens aperture and the shutter speed.

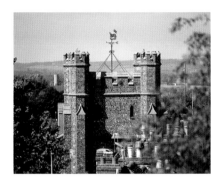

Metered exposure

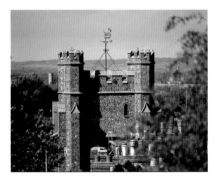

–1/2 stop

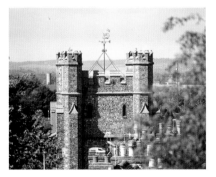

+1/2 stop

To set the level of compensation to be applied

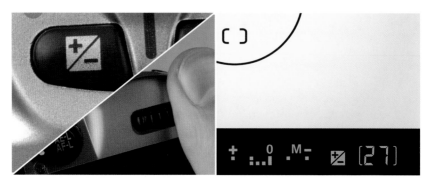

1) Depress the exposure compensation button and turn the main-command dial until the required amount is shown in the top LCD panel.

2) This amount is also shown in the viewfinder LCD.

⚠ Common errors
Remember to reset the amount of compensation to 0.0 to resume normal operation. Otherwise the camera will be making incorrect exposure settings (in auto) / readings (in manual) and your photographs may come out under- or overexposed as a result.

To reset exposure compensation to no compensation applied

1) Press the exposure compensation button and simultaneously turn the main-command dial until **0.0** appears. The ☒ symbol will disappear from the top LCD panel and from the viewfinder LCD.

Tip
The level of exposure compensation remains fixed and the ☒ symbol remains in the viewfinder LCD panel and on the top LCD panel until it is reset.

Auto-bracketing

In some lighting conditions it is impossible to calculate the correct exposure, or you may want to see the effects of different exposure settings. In this case you can bracket your exposures using the auto-bracketing function.

When you bracket your exposures the camera takes more than one picture of a scene at different exposure settings. For example, when photographing landscapes I will often take one image at the recommended meter reading, a second identical shot at half a stop below the recommended meter reading and a third at half a stop above the recommended meter reading. I end up with three identical images each with a different exposure value. If my original calculation was slightly out, one of the bracketed images will almost certainly have been taken at a correct exposure setting.

Underexposed

Overexposed

'Correct' exposure

To turn on auto-bracketing

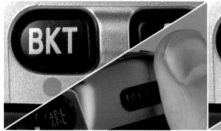

1) Simultaneously press the 'BKT' button on the rear of the camera and rotate the main-command dial one click. The BKT symbol will appear on the top LCD panel and the 🔲 symbol will flash in the top LCD panel for around eight seconds.

2) In auto-bracketing mode the camera allows you to select the sequence and number of shots taken. To set the bracketing sequence, simultaneously press the BKT button and rotate the sub-command dial until the required sequence is displayed in the top LCD panel. The sequence is displayed as per the following table.

Number of shots	Compensated EV
Two	0 and +0.5
Two	0 and −0.5
Two	0 and +1
Two	0 and −1
Two	0 and +1.5
Two	0 and −1.5
Three	0, −0.5 and +0.5
Three	0, −1 and +1
Three	0, −1.5 and +1.5

Bracketing in manual exposure mode

Bracketing can also be performed when shooting in manual exposure mode. Turning on the bracketing function, and selecting the bracketing sequence is done as described above. In manual exposure mode, the shutter speed will alter, while the lens aperture you have selected remains the same.

Taking the pictures

When auto-bracketing is selected, and once you have selected the number of frames to be taken and the sequence those frames are to be taken in, press the shutter release button. In single frame advance mode bracketing is performed one frame at a time. In continuous advance mode the shutter will fire the relevant number of frames so long as the shutter release button remains depressed. Once the full sequence has been completed the shutter will deactivate until the shutter release button is released and pressed again.

⚠ Common errors

It is easy when shooting moving subjects to forget at which point in a bracketing sequence you are at and you may end up completely out of kilter. To avoid this happening switch off auto-bracketing.

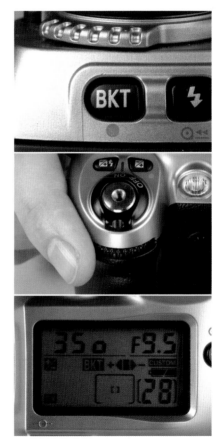

Turning auto-bracketing off

1) Remember to switch off the auto-bracketing function once you have finished using it. To do this, press the 'BKT' button and rotate the main-command dial one click. The 🔲 symbol will disappear from the top and LCD panel. To cancel bracketing mid-sequence turn the auto-bracketing function off, as described above.

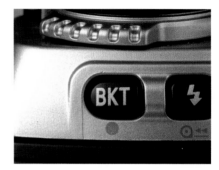

Notes

In programmed-auto mode the camera alters both shutter speed and lens aperture when performing auto-bracketing. In shutter-priority-auto mode the F80 / N80 adjusts the lens aperture only, and in aperture-priority-auto the shutter speed is adjusted.

If exposure compensation is set then bracketing will combine with the exposure compensation values. Bracketing combined with flash

bracketing output levels can be performed when a Speedlight is used.

If you finish a roll of film mid-bracketing sequence the F80 / N80 will continue with the sequence once a new roll of film has been loaded, even if the camera is switched off in between times so remember to cancel this operation if you do not wish the camera to continue.

Long-time exposure

For long-time exposures, beyond 30 seconds, the F80 / N80 has a 'Bulb' function, which opens the shutter to remain as long as the shutter release remains depressed.

To operate the F80 / N80 in 'Bulb' mode set the exposure mode to manual. Rotate the main-command dial until the symbol 'BULB' appears in the top LCD panel and viewfinder. Rotate the sub-command dial to set the desired aperture. Press the shutter release button to make the exposure, holding it depressed for the required time. Using a fresh set of lithium batteries, an exposure of up to six hours can be made.

⚠ Common errors

To avoid camera shake when operating the camera in 'Bulb' mode it is essential to mount the camera on a tripod. It is also advisable to operate the shutter release via one of the remote control accessories and cover the eyepiece with the supplied eyepiece cap (DK-5) to avoid stray light affecting the film.

Firing the shutter

The shutter release is neatly positioned to give the camera a solid feel in the hand. Pressing firmly but gently on the release button will fire the shutter.

⚠ Common errors
When using the shutter release button, make sure the camera is held firmly and squeeze the release slowly. Rapid pressing of the button may result in camera shake or sloping horizons.

Multiple exposures (ME)

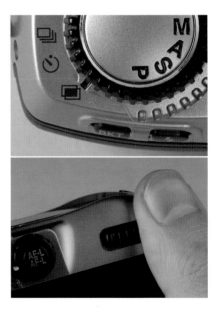

The F80 / N80 provides a function for multiple exposures allowing more than one exposure on the same film frame. Press the film advance mode selector lock and turn the film advance selector dial to ▣. Rotate the main-command dial while pressing the exposure compensation button to set the necessary exposure compensation.

The guides for exposure compensation are –1 EV for two exposures, –1.5 EV for three exposures, –2 EV for four exposures and –3 EV for eight or nine exposures.

Taking the first shot

1) To take the first shot, press the shutter release button. The film will not advance and the ◼ symbol flashes in the viewfinder as a reminder that the first shot has been taken. You can cancel multiple exposure at any time by simply turning the film advance mode selector to any other position than ◼.

Taking subsequent shots

1) To take the second and any further exposures, compose the image in the viewfinder and fire the shutter.

Note
When data imprinting is being used on the F80S / N80S then the information for the first frame only is printed.

Tip
Try a few test shots before doing serious multiple exposure work, since the exposure compensation is dependent on the shooting situation. If the background of the subjects being photographed is dark or black, no exposure compensation is necessary but don't overlap the subjects.

⚠ Common errors

Film advance is not stable near the beginning and end of a roll of film, and frames may shift slightly in multiple exposure mode, leading to incorrectly aligned images. It is recommended to make multiple exposures closer to the middle of the roll of film.

Other functions and controls

Custom functions

The F80 / N80 has a set of custom functions that let you customize your camera for optimum performance under different operational conditions. These settings can be selected via the camera by turning the exposure mode select dial to the CSM symbol and using the main- and sub-command dials to select functions and settings respectively.

Viewfinder dioptre

A viewfinder dioptre is included with the viewfinder and allows specific adjustment of the eyepiece to suit near- and far-sighted photographers, within a range of −1.8 to +0.8.

Tip

To ensure the image is in focus in the first instance select a subject and use the autofocus function. Then lock the focus using the 'AE-L/AF-L' button in default setting.

To set the dioptre

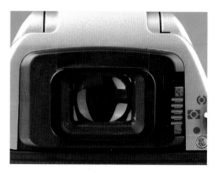

Remove the rubber eyecup and slide the dioptre adjustment switch until the circle on the focusing screen appears sharp. The dioptre control is very close to the viewfinder so take care not to poke or scratch the eyepiece with your fingernail. Replace the eyecup when you are happy with the focus.

Illumination switch

In dim light the top LCD panel can be illuminated to aid visibility.

To turn the illumination on

1) To turn the illumination on, hold the illumination button down. A blue/green light will illuminate the LCD panel. The light will automatically switch off after eight seconds or after the shutter release is fired.

Built in Speedlight

There is a built-in Speedlight flash unit, with a guide number of 12m at ISO 100. The unit covers a wideangle view of 28mm and also offers flash bracketing and exposure compensation of ±3 stops in 1/2 stops. The sync speed is 1/125sec, though lower speeds can be selected.

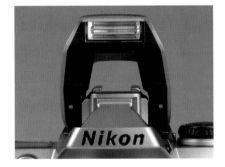

Operation of Speedlight

1) The Speedlight is situated within the pentaprism housing and opened via flash-release on the left side.

2) A selection of flash modes are available. To select the required mode, depress the flash mode button and rotate the main-command dial until the desired flash mode is displayed in the top LCD panel.

Flash modes

Auto balanced fill-in-flash

In auto the camera decides everything, setting the correct aperture and shutter speed on the camera and the correct output of the flash. It analyzes the brightness, subject reflectance and contrast of the scene an instant before you take the photo, to determine the correct level of flash to output. The shutter speed is set at 1/60sec or 1/125sec in programmed-auto and aperture-priority-auto modes while in shutter-priority-auto and manual exposure modes, the shutter speed can be at 1/125sec or slower. As a safety device, even if you attempt to set a higher speed the camera will stop at /125sec.

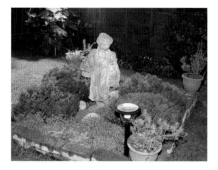

Slow Sync

In programmed-auto and aperture-priority-auto exposure modes, you can select slow sync if you wish to shoot at a slower shutter speed than 1/60sec.

Rear-curtain sync

Normally the flash will fire at the beginning of the exposure, but more creative effects can be achieved using rear-curtain sync. In this mode, the flash fires just before the rear (or second) curtain of the shutter begins to move. This is useful if you want to create a streaked light effect that trails the subject.

Red-eye reduction

The red-eye reduction lamp fires an instant before the shutter release to contract the subject's pupils and reduce the appearance of red-eye. Rather than use a series of pre-flashes, common on many cameras, the F80 / N80 uses the AF assist illuminator for this purpose.

Flash exposure compensation

In the same way as you can compensate for exposure it is possible to adjust the flash output level on the F80 / N80. Press the flash exposure compensation button and rotate the main-command dial. A setting covering −3.0 to +1.0 EV in 1/2 stop increments can be selected. This is especially useful in close-up work, where the standard output of the flash may 'blow out' the subject, or in instances where the meter may be fooled.

Accessory shoe

The standard finder fitted has an ISO-type hotshoe, which allows direct mounting of dedicated electronic flashguns. You may have noticed the lack of a PC (Power Cord) socket on the F80 / N80, to connect external flash or studio lights. The F80 / N80 accepts a standard X sync hotshoe mounted PC adapter to add external facilities.

When no flash is mounted it can also be used to attach other useful accessories, such as a spirit level.

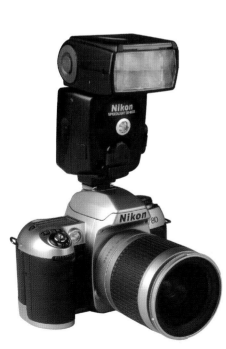

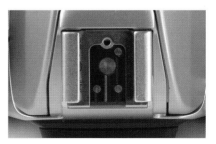

Custom functions

The pre-set factory settings and optional custom functions are detailed in the table below:

Function #	Description	Factory setting	Custom options
#1	Automatic film rewind	Activated	Disabled
#2	Reset to DX film speed setting for new film	Activated	Disabled
#3	Auto-bracketing	No change, minus, plus	Minus, no change, plus
#4	On-demand viewfinder grid lines superimposition	Off	Displayed
#5	Viewfinder illumination of AF brackets	Automatically illuminated in low light	1 Cancelled 2 Always on
#6	Focus area selection	Normal selection	Allows successive rotation of AF area selection
#7	Auto exposure lock	Disabled	Enabled
#8	Automatic film advance	Disabled	Enabled (with power on)
#9	Closest subject priority dynamic AF in single servo AF	Activated	Disabled
#10	Closest subject priority dynamic AF in continuous servo AF	Activated	Disabled

Function #	Description	Factory setting	Custom options
#11	AE/AF-Lock operation	Simultaneous lock	1 AE-Lock only 2 AF-Lock only 3 AE-Lock remains locked until second press of button 4 AF begins on depression of button
#12	Command dial functions	Main-command for shutter speed, sub-command dial for aperture	Main-command for aperture, sub-command dial for shutter speed
#13	Film rewind	High speed	Quiet rewind
#14	Multiple exposure	Single shutter release	Continuous shutter release
#15	Time set for auto meter switch off	6 seconds	4, 8, 16 seconds
#16	Self-timer delay	10 seconds	2, 5, 20 seconds
#17	Illuminate LCD by pressing any function button	Disabled	Activated
#18	AF assist illuminator	Activated	Disabled
#19 (F80S / N80S)	ISO film speed imprinting between frames	Auto	1 Below ISO 25 2 ISO 32–80 3 ISO 100 4 ISO 125–200 5 Above ISO 250

What each function does

Function #1 **Automatic film rewind options**
The factory default (0) setting automatically rewinds the film at the end of the roll. However, by setting the custom function to 1 you can override this and rewind the film by simultaneously pressing the two rewind buttons for one second or longer.

In the field There may be situations where the whirring of the film rewind is intrusive, even in quiet mode, during a wedding service for example and you wish to rewind the film later.

Function #2 **Reset to film speed setting for new film**
The default setting (0) will reset the camera to read the DX code on the film canister when you load a new film, even if you manually set the ISO speed manually for the first film. Choosing option 1 will allow you to replace the new film and keep the ISO rating that was set for the previous film.

In the field There may be times when you are shooting several films at a higher or lower ISO speed than the films' natural speed. Having to adjust the ISO every time you load a new film can waste time.

Function #3 **Auto-bracketing order**
When you activate the auto-bracketing option on the F80 / N80 the camera takes the sequence of pictures as no change (as per the meter reading), minus (underexposed from the meter reading) and plus (overexposed from the meter reading). By selecting 3-1 in function #3 you can change the sequence to minus, no change and plus.

In the field When reviewing images on a light box I find the customized sequence of minus, no change and plus easier to work with. It just seems more logical.

| **Function #4** | **On-demand grid lines**
| | A unique feature at the time of the F80 / N80's launch, a set of grid lines can be activated, superimposed on the viewfinder's screen, by selecting function 4-1.

In the field Used as a compositional aid, the grid lines can be used to visually line up horizons, or as a positioning guide. They can also be used to check and correct for converging parallel lines within an image.

| **Function #5** | **AF area illumination**
| | In the factory setting, the AF brackets within the viewfinder are briefly illuminated in red, depending on the subject brightness. This feature can be turned off (option 1) or the illumination can be permanently on (option 2).

In the field There may be times when the red glow is distracting, or in certain low light or low contrast situations the easily seen red lines are clearer than the standard black lines normally seen in the viewfinder.

| **Function #6** | **Focus area selection**
| | In the default setting (0), the focus area is selected by pressing the focus area selector in the desired direction. Switching the custom mode to option 1, allows the focus area to be changed continuously in the same direction.

In the field Rather than run your thumb over the controller as if it's a video game pad, you may prefer to use the AF area selector at the same pressure point. For example, when the bottom of the focus area selector is pressed, focus area continues to change from top, middle, bottom and so forth. So focus area can be changed without pressing the opposite position of the focus area selector.

| Function #7 | **Auto exposure (AE) lock**
With the F80 / N80 set at the factory setting, depressing the shutter release button halfway will activate the light meter. If you set custom function #7 to 7-1 the F80 / N80 will activate and then lock the exposure as long as the shutter release key is depressed.

In the field This is quite a useful feature when, for example, you want to take a spot meter reading from a part of the subject that isn't the central point of focus. By taking the meter reading and then locking it you can re-frame the picture without losing your chosen exposure. Of course, you could achieve the same result by using manual metering mode. |
| --- | --- |
| Function #8 | **Automatic film advance**
When you load a film into the F80 / N80 the film will advance to frame 1 as soon as the camera back is closed. Selecting custom function 8-1 will advance the film to frame 1 only after the back is closed and the shutter release is fully depressed.

In the field This can be useful as you can't take pictures until the film is wound on which can serve as a reminder to check your settings such as ISO etc, before you begin shooting. |
| Function #9 | **Closest subject priority dynamic AF in single servo AF**
This is enabled as standard, but can be turned off by selecting 1 in the custom menu.

In the field The factory setting will allow dynamic AF to lock onto the closest subject and track it as it moves, you may wish to add some motion blur or focus on a subject past the closest subject. This is useful in a sports environment, for example. |

Function #10 **Closest subject priority dynamic AF in continuous servo AF**

In continuous servo AF, this option is disabled. Selecting custom function 10-1 enables the option.

In the field For sports or wildlife photography, for example, it may be useful to have continuous tracking of the closest subject.

Function #11 **AE-L/AF-L button**

The factory setting of the F80 / N80 offers simultaneous locking of both auto exposure and autofocus using the 'AE-L/AF-L' button. Choosing option 1 in custom function #11 offers AE-Lock only; option 2 is AF-Lock only. Option 3 offers AE-Lock, which remains locked until the button is pressed for a second time. Option 4 starts autofocus operation when the 'AE-L/AF-L' button is pressed.

In the field There may be times when your exposure needs to be locked on a subject, while the AF remains independent, For example if your subject is moving but the lighting conditions are constant. In this case choose function 11-1. Conversely a situation where the subject is static but the light is changeable may require option 11-2.

If you are taking several frames of the same subject and need the exposures to be same throughout, then option 11-3, may be useful. The second press of the 'AE-L/AF-L' button will release the exposure lock ready for your next subject or situation. Option 11-4 takes the onus of the AF operation away from the shutter release button, which normally starts the AF and shifts the AF power to the 'AE-L/AF-L' button. The main situation where I have found this useful is when I have taken precise spot readings and used the shutter release to lock exposure, while recomposing and then focusing afterwards with this option.

Function #12

Command dial functions

The default setting has the main-command dial operating the shutter speed settings and the sub-command dial operating the aperture. By selecting this in the custom menu the controls are swapped, main-command for lens aperture and sub-command for shutter speed.

In the field This is an example of personal preference. If aperture-priority-auto is your preferred and most used exposure mode, then you may find it preferable to control aperture with the main-command dial, for example.

Function #13

Film rewind

A quiet rewind function is available, which rewinds the film slightly slower than the default option.

In the field I personally find the noise difference negligible in this mode, and prefer the higher speed. However, there may be times when even the slightest reduction in noise may be useful, such as during a wedding service, or in a hide.

Function #14

Multiple exposure

In the standard mode, the multiple exposure function only works in single drive mode. This custom function allows you to change to continuous drive mode.

Function #15

Meter on duration

When you lightly depress the shutter release button on the camera it activates the meter, which remains activated for six seconds after the shutter release button is no longer depressed. You can change the length of time the meter remains activated to four, eight or sixteen seconds via the sub-command dial.

Function #16

Self-timer delay

The self-timer is set to fire the shutter after ten seconds. You can change the duration of the timer to two, five or ten seconds.

In the field Ever forgotten your cable release? The self-timer can make an excellent alternative to firing the shutter while minimizing camera shake. When using the self-timer under these circumstances I usually set it to two seconds – saves me hanging about too long in the cold!

Function #17

LCD illumination

The F80 / N80 has a LCD illumination button next to the LCD panel. Custom function 16-1 allows you to use any button on the camera to operate the LCD's back-light.

In the field If you are shooting in a dark location, it is often useful to have the LCD lit up so you can keep a constant check on the settings and information in the LCD panel. By half depressing the shutter release, for example, you can save valuable shooting preparation time.

Function #18

AF assist light

The AF assist illuminator activates in low light situations automatically, in order to help the AF find and lock onto the subject. The light can be disabled by selecting custom function 18-1.

In the field Whilst the AF assist light is extremely useful and enables the camera's autofocus system to work efficiently, it may not be so helpful during an all-night badger watch.

Function #19

ISO speed imprinting (F80S / N80S only)

On the Nikon F80S / N80S, it is possible to imprint the ISO speed rating between frames. The factory setting does this automatically, but a series of options in the custom menu allows you to override and print your own set.

Chapter **3**

Into the field

So, that's the theory out of the way. But how does the F80 / N80 perform in the field and how do you get it to do what you want it to, when you want it to – all of the time?

One of the questions I'm asked most often is, 'Which camera takes the best pictures?' There is more than one answer to that question but in truth it is not the camera that takes the pictures, it is the photographer. One of the keys to photography is knowing your camera so well that the operation becomes instinctive. Only then can you concentrate on the important part – the picture.

Now, as we've seen from the previous chapter, the F80 / N80 has more than enough functions and technological wizardry to deliver in most situations. But all that technology is wasted if, in the field when it matters, you're scrambling around in your rucksack for the manual – or this technical guide! You wouldn't expect a surgeon to perform an operation with a copy of 'Grays Anatomy' open in front of him, while simultaneously reading the manual for the patient's life support machine. Photography is no different – well, perhaps a little less dangerous! In the hands of an inexperienced user the camera won't deliver the results on a consistent basis, if at all. Learn how to use it, however, so that its operation becomes second nature – an extension of your vision – and the results will be noticeable on the films you expose. Much of this is

just practice. After all, when you first start to drive you have to think about what you're doing. The time soon comes, however, when you no longer think about 'mirror, signal, manoeuvre', you just do it – subconsciously. And if you're serious about your photography (and having bought an F80 / N80 I'm assuming you are) then gaining the same level of familiarity with your camera should be your aim. That's what the pros do and that's one of the reasons we can spend more time thinking about composition, artistry and creativity, rather than worrying about f/stops and apertures.

The purpose of this chapter is to take some of the theory we covered in Chapter 2 and relate it to the real world. Of course, it will be impossible to cover every eventuality, and that's not my aim. What I want to illustrate here are some of the simpler things you can do to get the F80 / N80 working for you; to get you in control of the camera rather than having the camera controlling – or at least influencing – your actions.

The whole of this chapter is based on real photographic experience. I admit that some of it you won't agree with. And that's OK. I'm not advocating that you copy everything I do with my camera. Instead, take the knowledge shared here and adapt it to your own circumstances and

uses. As I said, the aim of this chapter is to get your F80 / N80 working for *you*.

Acting naturally

Whenever I acquire a new camera the first thing I do is familiarize myself with its layout. Over the years this has become a longer process (my first real camera was a fully manual Nikkormat. It had just eight buttons and levers and an instruction manual that ran to all of four pages!), but one that is essential if I'm to get the very best out of my investment.

I break the process down into basic, intermediate and advanced functions. Starting with the must-haves, such as turning the camera on, changing lenses, switching between AE modes and AF modes, focusing, film advance and exposure compensation, I practice working with the camera while enjoying a beer in the comfort of my armchair. My wife thinks I'm nuts but, when I'm finished I can do all those things with my eyes closed. Over the top? Maybe. But there have been many occasions when all that practice has paid off in the field, and I've ended up with commercially saleable images that I would otherwise have missed. And simply because I no longer had to think about the basic functions they just happened naturally.

Make the camera your own

The F80 / N80 is a highly customizable camera. While the benefits of some of the custom settings may not be obvious, the first exercise is to set it so that it operates more closely to your needs. The camera could be set up to favour wildlife photography or landscape work, for example. Some of this customization may be trial and error, and will probably change over time. Now, however, the camera is set to really perform quickly and efficiently for your own style of photography.

Once you have set the custom functions I would again advise you to practice using the camera in its customized state.

Be prepared

In my field of photography – and I'm sure I'm not alone – Murphy's law says that the killer image happens when your camera is safely tucked up in its backpack or camera bag. Because of this, when I'm working, my camera is always to hand, switched on and usually fitted with one of two zoom lenses depending on what I'm photographing: a 24–120mm zoom when I'm working predominantly on landscapes and an 80–400mm vibration reduction zoom when wildlife is my priority. This way, if a photo opportunity were to appear unexpectedly, nine times out of ten I'm ready for it.

As well as being switched on, the camera is also set to its most functional settings for my style of photography. The exposure mode is set to aperture-priority-auto in matrix metering mode. AF is set to continuous servo in dynamic focus area mode and film advance is set to continuous mode. I also keep it loaded with a relatively unused roll of film (if a roll has gone beyond 25 frames I'll usually replace the film, if I get the chance to, during a break in shooting).

Again, you might think me paranoid. But I'm working from experience and operating in this way means that I miss fewer shots.

When I'm actually working in the field I follow a few additional rules. As well as keeping plenty of film to hand I carry spare batteries. When the batteries in the camera begin to die, I replace them as soon as possible. One of the challenges of wildlife photography is anticipating the shot. That's a lot easier to do when all I'm thinking

about is what the animal is doing rather than worrying if my batteries will last through to the next shot.

An F80 / N80 in the hand...

While there are many things about this camera that make it quick and easy to use, there are some things that manage to annoy the pants off me. For example, you have probably noticed by now that several controls on the F80 / N80 require two functions to be performed. Nikon state that this is a safety feature of the camera, ensuring nothing is done by accident - a bit like your computer asking you to confirm irreparable actions. While this may be so, and a great idea in the test lab, it can get a bit annoying, particularly when shooting in conditions that are far from ideal. Try switching between drive modes when you're wearing a pair of thick gloves in the depths of winter, for example. However, the compact nature of the camera and comfortable grip make this a light camera to carry yet one that feels secure in the hand.

Another less than ideal design is the focus mode selector switch. Because of the low profile and milled edge, it pays not to cut your nails to short in order to gain a grip and some leverage.

The other eventuality I plan for is the tripod. I currently use a Manfrotto with a quick-release pan and tilt head. A quick-release plate

is always attached to the camera's base so that setting up the camera on the tripod becomes a quick and simple task.

You will note that everything I've talked about so far is based around speed of operation. That's because often in photography speed can be the difference between success and failure. Depending on your particular photographic interests and personal style, speed may not be all important. But ease and speed of use are two of the F80 / N80's greatest selling points and some of the above disciplines are discussed in order to help you respond to the situations that appear in front of you.

Controlling **exposure**

Besides composition and use of light, the two most important elements of a compelling photograph are correct exposure and accurate focus. Defining what the words 'correct' and 'accurate' really mean when applied to exposure and focus is a complicated affair and not a topic for this book. Instead, the next part of this chapter will look at getting the most out of two of the F80 / N80's most advanced features: TTL exposure control and autofocus.

TTL exposure control

The F80 / N80 has three TTL metering systems: 3D matrix, centre-weighted and spot. The area of the scene that influences the camera's calculations varies depending on the system you are using and will affect the way the final image is recorded on the film. The decision you have to make is, which area of that scene is most important to the photographic message you're trying to communicate and which of the three available systems best suit the prevailing conditions relative to your subject.

There are also four different exposure modes: programmed-auto, aperture-priority-auto, shutter-priority-auto and manual. Each of these modes gives you varying degrees of control over the exposure settings. Which of the four modes you should use in any given set of circumstances will again depend on how you want the final image to appear on film, and understanding the relative effects of each on the way a scene is recorded will go along way to ensuring that the final image lives up to your photographic expectations.

Because programmed-auto mode allows you very little control over the exposure settings I have largely ignored it in this section of the

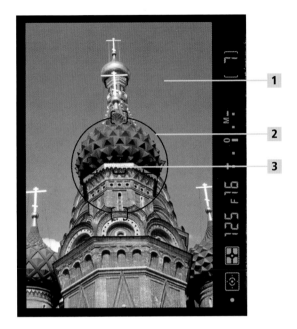

book. To be honest, I rarely use it. The three exposure modes I'm going to concentrate on are aperture-priority-auto, shutter-priority-auto and manual.

1 3D colour Matrix metering (▦) exposes for the whole scene.

2 Centre-weighted metering (◉) places emphasis on the light level in the 12mm reference circle.

3 Spot metering (⊡) reads light levels from a 4mm circle.

The illustration above indicates which area of the viewfinder the F80 / N80 takes light-level data from and in what proportions, depending on the metering system selected. Understanding how the camera gathers light-level data will make selecting the right metering system for any given lighting conditions that much easier, and your exposures will become more consistent and accurate.

Aperture-priority-auto exposure mode

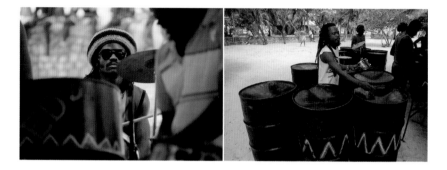

This is the mode I have set most often and is a popular choice amongst many pros. Aperture-priority mode gives you control over the lens aperture while the camera sets an appropriate shutter speed, depending on the meter reading and any exposure compensation you've dialled in. Taking control over the lens aperture means you have control over the depth of field. For front to back sharpness – large depth of field – you need to select a small aperture, e.g. f/16, f/22 or f/32. For shallow depth of field, for example where you want to purposefully blur the background, then you need to set a large aperture, e.g. f/2.8, f/4 or f/5.6. Of course, these are just examples and the exact settings you use for any single image will depend on the specific equipment used and the conditions prevalent at the time.

Manual exposure mode

With the F80 / N80 set to manual exposure mode you take complete control over the exposure settings, relying on the camera to indicate an exposure reading via its TTL meter. Typically, I use manual mode when I want to make a number of adjustments to the exposure setting because of very complex lighting conditions, or when using certain types of filter, such as neutral-density (ND) graduated filters. Using manual exposure mode also means I never have to use the AE-Lock function, since once I've dialled in the lens aperture and shutter speed settings, they will remain in place until I change them.

Shutter-priority-auto exposure mode

In shutter-priority-auto mode you have control over the shutter speed while the F80 / N80 sets an appropriate aperture to give an accurate exposure setting, taking into account any manual adjustments you've made. Controlling the shutter speed means you have control over the way motion is depicted in the final image. To freeze subject action or motion, such as a running bear or a waterfall, then a fast shutter speed is needed, e.g. 1/125sec, 1/250sec or 1/500sec. At the opposite end, a slow shutter speed, e.g. 1/8sec, 1/16sec or 1/30sec, will blur subject action giving the appearance of motion in a scene.

So what?

So, now we've identified why you might choose certain exposure modes and metering systems, the next question is how to apply them effectively in the field? What follows are a series of images taken using each of the different exposure systems and modes. The purpose of these images and their respective commentaries is to help you relate the theory we've just discussed to the practice in real life.

Tip

Using too slow a shutter speed could result in camera shake if the camera is unsupported. When using aperture-priority-auto and shutter-priority-auto exposure modes keep an eye on your shutter speeds. With a standard 50mm lens, a shutter speed of 1/60sec is the slowest most people can use. As a general rule the slowest shutter speed should not exceed the focal length of the lens. For example a 135mm lens should be used at a minimum of 1/125sec and a 300mm lens could be hand-held at a minimum of around 1/250–1/500 sec for optimum results.

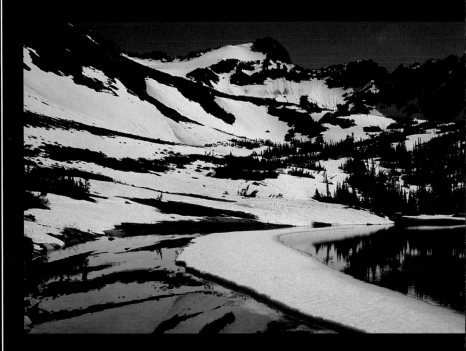

REFLECTED TREES
Near Skagway, Alaska, USA

F80 / N80 settings:
Metering system –
spot metering;
Exposure mode –
manual.

In this image I felt the levels of contrast were too high for the matrix metering system to give me an accurate reading. Between the brightest parts of the scene, where the light is reflecting off the snow, to the shadow of the watery reflection of dark green pines there was a very significant variation.

Although matrix metering is very often to be trusted, you get a feeling about some shots. The disadvantage of matrix metering is that you don't know whether the meter is taking to much or too little account of various elements of the scene. Here I switched to spot metering mode and took three different readings. The first reading was taken from the bright area of snow in the middle of the mountain. The second reading was taken from a mid-tone I found in the mountain and the third reading was taken from the dark water in the foreground. I switched the exposure mode to manual as I was going to make a few adjustments because the

light levels were pretty constant. I was fairly confident about my mid-tone being spot on, but the choice of metering pattern also allowed me to judge where my whites and blacks were on the exposure scale.

There are very few absolutely correct answers in photography. Most exposure situations can be resolved in a number of different ways (even if they all end up with the same exposure). This scene is a classic of its type.

You have a subject that is a perfect mid-tone – but you have to choose the right place to meter that mid-tone from. There is also a great deal of back-lighting that might affect the meter depending on the pattern selected.

In short, matrix metering might make a fine job of balancing the back-light and the mid-tones. The centre-weighted

F80 / N80 settings:
Metering system –
spot metering;
Exposure mode –
shutter-priority-auto.

pattern would probably give too much emphasis to the back-lighting and central flood-lighting at the expense of the mid-tones, for these reasons spot metering was the option which I ended up choosing.

In these low light levels I knew there was a need for a longish exposure but it still had to be hand-held so I didn't want to stray too far below 1/60sec. I settled on 1/45sec and it transpired that the meter told me, when I pointed it at the mid-tones on the arch, that the aperture derived from these readings was wide open (f/2.8 with the lens I was using). Selecting shutter-priority-auto is useful on occasions like this as it allows you to set limits on what you know yourself to be capable of hand-holding. Had I used aperture-priority-auto and the light levels had been a little lower I would have set it wide open anyway and been tempted to hand-hold at a longer shutter speed. In my experience the feeling that 'the shutter is as fast as I can get it' rarely results in shake-free results. Better to abandon hand-holding in favour of using the tripod (which I stupidly hadn't brought), or if you get down to silly exposure times (i.e. slower than 1/8sec) then save your film and abandon the shot.

BACK-LIGHTING AND FLOOD-LIGHTING
Marble Arch, London, UK

Largely even tone conditions

SHADOWS ON A WALL
Civitavecchia docks, Italy

F80 / N80 settings:
Metering system –
centre-weighted metering;
Metering mode –
aperture-priority-auto.

This is one of those situations where the situation looks an awful lot more complicated than it was. I was in a relaxed state of mind and I simply selected centre-weighted metering and aperture-priority-auto and let the camera do the rest. Matrix metering can sometimes pull really complex scenes back together in a nearly magical way. However, on all cameras with complex metering patterns where you cannot know what emphasis is being given to which part of the image, it is better to go to a more old-fashioned metering system – centre-weighted. The worst that would happen might be a touch of overexposure, but that would only add more shadow detail anyway, so I was relaxed about the outcome.

Using **autofocus**

The F80 / N80 has two different AF area modes – single area and dynamic. In single area mode the focus is set to one of the five focus area sensors and if the subject moves out of that sensors range then you will need to refocus. Therefore, single area focus mode is best suited to static subjects, such as portraits, still life or landscapes, or for use when panning the camera with a moving subject, such as following the line of a racing car. In dynamic focus area mode focus is fluid. The camera detects the movement of the main subject and shifts between focus sensors to track its movement around the picture space. For this reason, dynamic area focus mode is designed for photographing moving subjects, such as in wildlife and sports photography. Within this mode is closest subject priority dynamic AF, which tracks the subject closest to the camera, and is useful for macro photography as well as other situations.

You can also select one of two focus modes: single servo or continuous servo. In single servo mode, once focus has been locked it will not change even if the subject moves. In continuous servo mode the F80 / N80 will continue to track the movement of the subject as it changes position in the

viewfinder and adjusts focus accordingly. Single servo mode, then, is best suited to conditions where the camera-to-subject distance is constant, whereas continuous servo mode works more effectively with subjects where the camera-to-subject distance is variable.

Putting it all into practice

So how does all that work in the field? In the same way I demonstrated the use of exposure modes and systems in the previous section, I have used the following series of images to illustrate the use of the autofocus system in a real world environment.

It may seem a bit extreme to use the same mode for taking a picture of a man walking with a stick as you would do for a fast moving animal, but there is speed and then there is distance to speed ratio. The closer a subject gets to you, the more you need to adjust the focus. A slow-moving, near subject requires more work from the AF system than a distant fast-moving one.

I had decided to use a narrow aperture so I was going to be a little protected by depth of field, but nonetheless, sensible use of the correct focusing mode will always get you a better picture than merely hoping for the best.

SENIOR SEÑOR
Stone Island, Mexico

F80 / N80 settings:
Focus area mode –
dynamic AF;
Focus mode –
continuous servo.

Subject moving horizontally into frame

F80 / N80 settings:
Focus area mode – dynamic AF;
Focus mode – continuous servo.

This is another sledgehammer to crack a nut focusing situation. I brought the camera's full panoply of focusing tools into play on this shot not because the guys were moving quickly, rather because they were moving slowly. If the focus had been on single shot I could have refocused and recomposed every time I wanted a different shot, but it was quicker, easier and better to use the advanced focusing features. Although I had a narrow aperture and therefore lots of depth of field, I didn't want to waste it by focusing in the wrong place.

DRIFTING SURFERS
The Grenadines

This is another oddity of the realm of focusing, in that a waterskier may instinctively seem like a hard subject to focus on, and to a degree it is, but it is a very easy one to keep focus on. Why? Because the waterskier is at the end of a fixed piece of rope and will be the same distance from the pinion point of the rope. So the key is to establish focus and prevent the camera from getting any ideas about choosing a different distance to focus at. In fact the servo allows me to concentrate on the skier without the camera deciding to go for the full focus travel between each shot.

TRAVERSING WATERSKIER
In the seas off Tobago, West Indies

F80 settings:
Focus area mode – single area;
Focus mode – continuous servo.

Subject off-centre

Sometimes you get a nose for a scene, and you know an off-centre composition will work better than the instinctive desire to place subjects symmetrically and centrally. In the case of the Nikon F80 / N80, life couldn't be easier. Just select the far left-hand AF sensor and let the camera take the strain.

F80 / N80 settings:
Focus area mode – single area;
Focus mode – single servo.

SPHINX-LIKE POSE
Near Cairo, Egypt

Chapter **4**

Flash and the F80 / N80

Flash photography is one of those disciplines that can cause endless frustration to photographers. The problem is that the laws of physics govern flash exposure, and physics is a subject many people, including photographers, recoil from in horror.

The F80 / N80 simplifies flash use and removes the physics from much of the operation. On-board is a built-in Nikon Speedlight, which is ideal for everyday use, but better results can be had if you use a separate flash unit. Simply fit an external Nikon Speedlight directly on the accessory shoe, or via a remote connecting cord and even novices can produce a reasonable image.

To get the best out of the flash system, however, greater understanding of the techniques of flash photography is still necessary, in particular the way the camera is interpreting what it sees. So throughout this chapter we will explore not just the Nikon flash system, but also some of the fundamentals of using flash, including calculating flash exposure and applying flash in the field.

Where possible, I have tried to use layman's terms so as not to frighten you into turning the pages too quickly. Even so, flash photography is an art in itself and still requires a certain level of scientific explanation, so please stick with it! Throughout the chapter I will often refer to certain terms, which I will explain here. The guide number of the flash unit is a measure of its light output – the greater the number the greater the intensity of the flash. As well as providing a guide to the power of a given flashgun, guide numbers are needed to calculate flash exposure in manual exposure mode. Flash coverage refers to the focal length of the lens or lenses the flashgun is designed to work with. Recycling time is the amount of time it takes for the flash to recharge after firing. This is particularly important if you are operating the F80 / N80 in continuous film advance mode.

The Nikon flash system

The flash system available from Nikon is comprehensive. It can also be supplemented by flash accessories from non-proprietary systems produced by manufacturers such as Metz and Sunpak. In this section I will concentrate solely on the Nikon system, and some of the more useful accessories within it.

Built-in Speedlight

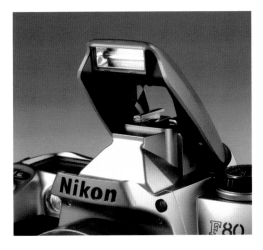

Most people's first port of call will be the pop-up Speedlight housed above the pentaprism. With a guide number of 12m at ISO 100, covering a sensitivity range of ISO 25–800, the flash is more than adequate for everyday use, performing acceptably at its standard default settings. The Speedlight is compatible with the majority of Nikon lenses from 28–200mm, though the 3D matrix balanced fill-in-flash will only work with D-type lenses.

The operation of the flashgun is carried out in the same way as with the external range of Speedlights listed in this chapter, but due to the limited power and lack of movements, you may soon find yourself restricted by the built-in Speedlight and wish to invest in a separate, more adaptable unit.

Flash sync modes

The F80 / N80 has five flash sync modes, enabling you to achieve a variety of flash functions in differing situations. To set the desired flash sync mode, rotate the main-command dial while simultaneously pressing the flash sync mode button.

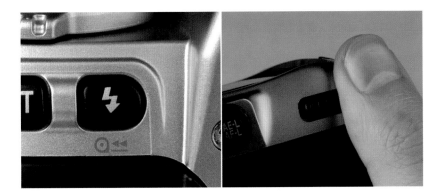

Front-curtain sync

Most everyday photography will require use of front-curtain synchronization. In this mode the flash fires as the first curtain of the shutter curtain opens, producing natural-looking photographs. The camera's shutter is automatically set at 1/60sec or 1/125sec in programmed-auto and aperture-priority-auto exposure modes.

When using Speedlights SB-24, 25 or 26 you must set their sync mode selector to 'Normal'.

Slow sync

In slow sync mode the camera sets a slower shutter speed, down to 1/30sec. In night-time shots this will allow more background or ambient light to record on the film, while still keeping the main subject properly exposed by the flash.

Rear-curtain sync

One of my favourites, rear-curtain sync mode fires at the end of the exposure. If you are shooting a moving subject, the available light becomes a streak that follows the flash-illuminated subject. If rear-curtain sync is chosen in programmed-auto or aperture-priority-auto modes, the camera will automatically set slow sync.

If you are using Speedlights SB-24, 25 or 26 you must set the Speedlight's sync mode selector to 'Rear'.

Red-eye reduction

The AF assist lamp also doubles as the red-eye reduction lamp. In this mode the lamp fires for approximately one second before the flash fires and the exposure is made. Red-eye occurs when the light from the flash hits the blood vessels at the back of the eye. In dark conditions the subjects' pupils will be wider, so the effect is more pronounced. By firing a light at the subject first the pupils will contract and lessen the effect. Speedlights SB-28/28DX, 27 and 26 have their own red-eye reduction lamps built in.

Red-eye reduction with slow sync

This repeats the red-eye reduction procedure and combines with the slow sync to record more background detail.

Tip
When using red-eye reduction, try to keep the camera and subject still. Because of the delay when using red-eye reduction, do not use it when a high shutter speed is your top priority.

SB-80DX

At the time of writing this is Nikon's most recent addition to its flashgun range, and has been designed to operate effectively with both film and digital cameras.

Electronic construction
Automatic Insulated Gate Bipolar Transistor (IGBT) and series circuitry

Flash exposure control
TTL automatic, non-TTL automatic and manual (adjustable)

Guide number (ISO 100, m)
38 – with zoom-head set at 35mm

Flash coverage
24–105mm in 5mm zoom steps. 17mm and 14mm with built-in wide flash adaptor. 14mm with soft dome attached

Film speed range
25–1000 ISO (in TTL auto flash mode)

Recycling time
Approximately 6 seconds

Dimensions (w x h x d)
70.5 x 127.5 x 91.5mm

Weight
335g (without batteries)

SB-50DX

The SB-50DX is a baby version of the larger SB-80DX, though it still possesses many of the functions of its bigger brother. It too is a recent entry to the Nikon range and similarly has been developed to meet the requirements of both film and digital media.

Electronic construction
Automatic Insulated Gate Bipolar Transistor (IGBT) and series circuitry

Flash exposure control
TTL automatic and manual (full power only)

Guide number (ISO 100, m)
22 – with zoom-head set at 35mm

Flash coverage
24–50mm in four steps (24mm, 28mm, 35mm and 50mm). 14mm with wide flash adaptor

Film speed range
25–1000 ISO (in TTL auto flash mode)

Recycling time
Approximately 3.5 seconds

Dimensions (w x h x d)
63 x 107 x 105mm

Weight
235g (without batteries)

SB-27

The Speedlight SB-27 is a compact-type flash unit with an automatic zoom range of 24–50mm and a swivel function for bounce techniques.

Electronic construction
Automatic Insulated Gate Bipolar Transistor (IGBT) and series circuitry

Flash exposure control
TTL automatic and manual (adjustable)

Guide number (ISO 100, m)
30 – with zoom-head set at 35mm

Flash coverage
Horizontal position: 24–50mm in four steps (24mm, 28mm, 35mm and 50mm)
Vertical position: 35mm, 50mm, 70mm

Film speed range
25–1000 ISO (in TTL auto flash mode)

Recycling time
Approximately 5 seconds

Dimensions (w x h x d)
107 x 70 x 97mm

Weight
340g (without batteries)

SB-22s

This economical compact Speedlight features an Automatic Insulated Gate Bipolar Transistor (IGBT) and series circuitry and offers TTL automatic control with the F80 / N80. Its small size and limited control make this the entry level, though still effective, model.

Electronic construction
Automatic Insulated Gate Bipolar Transistor (IGBT) and series circuitry

Flash exposure control
TTL automatic and manual

Guide number (ISO 100, m)
28 – set at 35mm

Flash coverage
35mm (28mm with wide-flash adapter)

Film speed range
25–1000 ISO (in TTL auto flash mode)

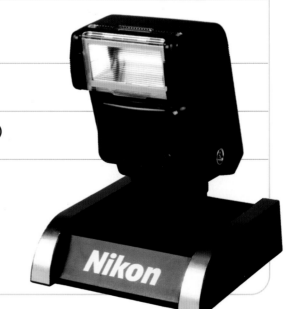

Recycling time
Approximately 5 seconds

Dimensions (w x h x d)
105 x 68 x 80mm

Weight
210g (without batteries)

SB-29s Macro

The SB-29s is a specialist macro photography flash. It consists of two built-in flash modules which remove distracting shadows. Experienced users of this type of flash comment that the lighting can appear flat. While this may be true, the SB-29s is a valuable tool when working in non-studio conditions.

Electronic construction
Automatic silicon controlled rectifier and series circuitry

Flash exposure control
TTL automatic and manual (adjustable)

Guide number (ISO 100, m)
At full power: 11 for both flash modules and 12 for single flash module. At $1/4$ output (manual mode): 5.5 for both flash modules and 6.0 for single flash module

Flash coverage
20mm – flash modules set horizontally; 24mm – flash modules set vertically

Modelling illuminator
Repeat firing at approximately 40Hz

Film speed range
25–1000 ISO (in TTL auto flash mode)

Recycling time
Approximately 3 seconds

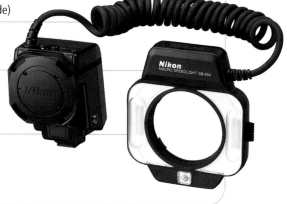

Dimensions (w x h x d)
Main unit – 119 x 133 x 28.5mm
Controller – 69 x 106.5 x 88.5mm

Weight
410g (without batteries)

Accessories

TTL remote cord SC-17 (1.5m)
For use with off-camera TTL flash.

TTL multi-flash sync cord SC-18 (1.8m) / SC-19 (3m)
Used to connect TTL flash units together.

TTL multi-flash adaptor AS-10
Allows the connection and control of up to three TTL flash units using the SC-18 or SC-19 sync cords.

High-performance battery pack SD-8A
The SD-8A is an external power source designed for use with the SB-80DX. It shortens the recycling time of the flash and enhances the flash capacity.

Power bracket unit SK-6(A)
The SK-6(A) is attached to the F80 / N80 via the tripod mount on the base of the camera. It provides an off-camera mount for the SB-80DX and remote flash capability. It can also operate as an external power source, in combination with the SB-80DX's own power source, reducing recycling times and increasing the number of flashes available.

Flash **fundamentals**

In manual flash exposure mode, correct exposure is governed and controlled by flash-to-subject distance and lens aperture. When the flash is fired the capacitor is completely emptied, meaning you cannot also control the amount of light being emitted from the flashgun.

With TTL flash exposure control, however, this is not the case and the capacitor is not necessarily fully emptied every time it is fired. The computers in the camera and flashgun calculate the exact amount of light needed to give a correct exposure and switch off the flash as soon as that amount of light has been emitted. In this way, you now have a greater level of control over the aperture used and, by default, depth of field.

TTL fill-in-flash exposure

1) At its most advanced, the process the F80 / N80 uses to determine correct flash exposure is quite complex and that it manages to complete the task in just the time it takes to fire the shutter is a minor miracle in itself.

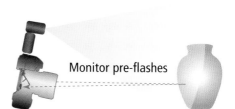

Monitor pre-flashes

2) When you lightly press the shutter release button the camera analyzes the distance information provided by the attached D-type lens. It then fires a series of imperceptible flashes (known as monitor pre-flashes). These flashes are reflected back from the subject. They enter the camera via the lens and are reflected from the shutter curtain (which has a known reflectivity) onto the TTL multi-sensor.

3) The camera then compares the pre-flash light with a calculation based on camera-to-subject distance information, the guide number of the flash used and the set lens aperture, and analyzes the result to determine either the segment(s) to use for the final flash control or the amount of fill-in-flash required to balance with the ambient light conditions.

4) Once all this has happened the shutter opens and the flash fires, controlled by the F80 / N80's computer and based on the calculations made during the above process.

TTL auto flash – automatic balanced fill-in-flash and standard TTL flash

For general flash photography the F80 / N80 operates in TTL auto flash mode, providing either balanced fill-in-flash – where the light from the flash is combined with available ambient light – or in standard flash mode, for very low light conditions and night-time photography. The type of TTL auto flash performed will depend on the limitations of the flashgun and lens combination being used, as well as the metering system and selected exposure mode.

3D multi-sensor balanced fill-in-flash

3D multi-sensor balanced fill-in-flash uses a combination of technology within the camera, the lens and the flash unit. Because of its advanced nature it can only be performed when the F80 / N80 is used in conjunction with D-type lenses – that have a built-in CPU, which provides the camera (and the flashgun) with distance-to-subject data. In this flash mode the flashgun will fire a series of imperceptible pre-flashes in between depressing the shutter release button and activating the shutter. The purpose of these pre-flashes is to allow the multi-sensor to measure the brightness, contrast and subject distance and then calculate the required flash output level, in conjunction with other exposure control information taken from the TTL metering system being used. The amount of light from the flashgun is thus controlled to ensure a correct balance between the available ambient light and the light from the flash.

Tips

I recommended using this mode for all general photography when the required equipment is available.

The F80 / N80 must be set to either matrix or centre-weighted metering for 3D multi-sensor balanced fill-in-flash to be performed. It will not work with the camera set in the spot metering mode.

Multi-sensor balanced fill-in-flash

This flash mode is performed when the F80 / N80 is used with non-D-type lenses. Multi-sensor balanced fill-in-flash works in exactly the same way as 3D multi-sensor balanced fill-in-flash but without the distance information.

Tip
I recommended using this mode for all general photography when the required equipment except the D-type lens is available.

Centre-weighted fill-in-flash

Centre-weighted fill-in-flash can be performed with any compatible AF lens. In this flash mode, the centre-weighted meter measures ambient light exposure. The F80 / N80's TTL flash sensor then automatically controls the flash output level. The system gives you a level of control by allowing you to alter the brightness value and flash compensation settings.

Tip
For auto fill-in-flash photography this is my last resort setting, used when neither 3D multi-sensor or multi-sensor modes are possible.

Standard TTL flash

This flash mode does not perform automatic flash output level compensation. The result is a correct exposure for the main subject and the possibility that the background will be over- (or more usually) underexposed. This is not necessarily a bad thing and it may be the effect you are looking for.

Tip
I recommend using this mode when the levels of light are extremely low, or at night, when fill-in-flash will have little effect on the brightness of the background in the scene.

System **compatibility**

The following tables illustrate the system compatibility of the F80 / N80 when used with different Nikon Speedlight flashguns and lenses. Also note that a lens hood should be removed before using the built-in Speedlight.

The built-in Speedlight can be used with 28–300mm CPU lenses, 28–200mm non-CPU Nikkor lenses and Series-E lenses. Using the Speedlight with the following lenses at focal lengths or shooting distances shorter than those recommended may result in vignetting and consequently underexposure.

Lens	Restrictions Minimum focal length	Exposure mode Minimum shooting distance
AF-S 17–35mm f/2.8 ED	35mm	1.5m
AF 20–35mm f/2.8	28-35mm	2m (at 28mm)– 0.7m (at 35mm)
AF 24–120mm f/3.5–5.6	28mm	0.8m
AF-S 28–70mm	50mm	0.8m
AF 28–85mm f/3.5–4.5	28mm	2m
AF 35–70mm f/2.8	35mm	0.8m
AF Micro 70–180mm f/4.5–5.6 ED	70mm	0.7m
AI-S/AI 25–50mm f/4	40mm	0.8m
AI-S 28–85mm f/3.5–4.5	35mm	N/A
AI 35–70mm f/3.5	35mm	1m
AI 28–45mm f/4.5	28mm	1m
AI-modified 50–300mm f/4.5	200mm	N/A
AI-S/AI 50–300mm f/4.5	135mm	N/A
AI 80–200mm f/2.8	105mm	N/A
AI-Modified 80–250mm f/4	135mm	N/A

Functions of Speedlight flashes in combination with Nikon F80 / N80, with an AF Nikkor lens attached.

	3D	Multi	TTL	A	M	Repeating	REAR	Red-eye	AF	SLOW	ZOOM
SB-80DX	3D	◉	TTL	A	M	⟨⟩	REAR	◉	AF	SLOW	ZOOM
SB-27	3D	◉	TTL	A	M		REAR	◉	AF	SLOW	ZOOM
SB-50DX	3D	◉	TTL		M		REAR	◉		SLOW	ZOOM
SB-22s		◉	TTL	A	M		REAR	◉		SLOW	
SB-23		◉	TTL		M		REAR	◉		SLOW	
SB-30		◉	TTL	A	M		REAR	◉			
SB-16B		◉	TTL	A	M		REAR	◉			
SB-16A				A	M		REAR	◉			
SB-29s		◉	TTL		M		REAR	◉			

	
3D	3D multi-sensor balanced fill-in-flash (with D-/G-type Nikkor lenses)
◉	Multi-sensor balanced fill-in-flash
TTL	Standard TTL flash
A	Non-TTL automatic control (with built-in flash sensor)
M	Manual control
⟨⟩	Repeating flash
REAR	Rear-curtain sync
◉	Red-eye reduction
AF	AF-assist illuminator
SLOW	Slow sync
ZOOM	Automatic power zoom

TTL auto flash operation

Operating TTL auto flash is the same, irrespective of whether the camera is performing balanced fill-in-flash or standard TTL flash.

1) First, set the camera's metering system and metering mode, referring to the tables on pages 118 and 119.

2) Turn the flash unit on.

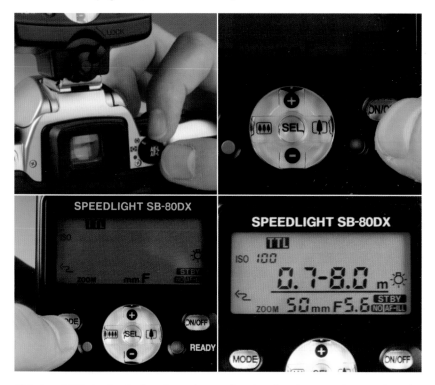

3) Select 'TTL' via the flash unit mode selector. After composing the picture ensure that the exposure settings are within the required range for correct exposure and that the lens is focused on the subject.

4) Using the shooting distance bars (or shooting distance tables for SB-23, 22s, 22 and 20) confirm the exposure and shooting distance. When the shutter is fired the flash will fire so long as the ready light is illuminated.

Tips

If, after the flash fires, the ready light blinks then the flash has fired at its maximum output level. This may indicate that the level of light is insufficient to expose the scene correctly. If this happens, check the shooting distance again and, if necessary, move closer to the subject or increase the lens aperture.

Selecting a wider lens aperture will increase the maximum shooting distance of the flash.

If subject distance remains the same, selecting a wider aperture will speed up the flash recycling time because less of the charge held in the capacitor will be used. Depth of field will be affected by changes in lens aperture.

Chapter **5**

Close-up with the F80 / N80

The breadth of the Nikon system, coupled with the F80 / N80's versatility, make it an ideal camera for close-up photography. While the fundamental rules of photography apply equally to the close-up world and the wider world, the equipment used in close-up photography is often very specialized. Also, as you explore the creative possibilities of close-up photography your requirement for such specialist equipment increases.

Reproduction ratio

One of the key aspects of close-up photography that you'll need to master is the reproduction ratio (RR). The RR denotes the relationship between the life size of the subject and the size at which it is reproduced on the film. A reproduction ratio of 1:1, for example, means that the image on the film is the same size as the subject in real life. Technically, a RR of 1:1 or greater is referred to as macro photography, though the term macro is increasingly used to describe any form of close-up photography. What determines the RR is the distance between the film plane and the subject, combined with the lens' focus setting.

The free working distance

Another term that you will become familiar with in close-up photography is 'free working distance'. This relates to the distance between the front element of the lens and the subject. At close quarters a living subject may become stressed and uncooperative. The proximity of the lens may also affect the lighting of the subject.

Technically, one of the greatest challenges you'll face in close-up photography is managing depth of field. In close-up work depth of field is very shallow and is affected by the RR and lens aperture used. The greater the RR and the wider the aperture, the less depth of field you will have to work with.

Many of the features of the F80 / N80 and its supporting system help you to manage these challenges effectively. A number of different accessories and combinations of accessories are available to produce images with a RR of up to 11x life size. Specialist lenses with focal lengths up to 200mm help to increase your free working distance. Also, the depth of field preview button gives you precise control over the area of acceptable sharpness – albeit with a little practice.

WET FLOWER HEAD
With close-up photography the aim is
generally to make small things look
big. By focusing from slightly further
away with a longer macro lens, it is
also possible to make big things look
smaller as I did here with the
70–180mm Micro Nikkor.

Reproduction ratios with Nikon accessories

1/8x	1/4x	1/2x	1x	2x	4x	8x	11x

Lens only

+ attachment lens

+ extension ring

+ bellows attachment

AF Micro-Nikkor 60mm f/2.8D, 105mm f/2.8D, 200mm f/4D IF-ED

AF Zoom-Micro Nikkor 70–180mm f/4.5–5.6D ED

PC Micro-Nikkor 85mm f/2.8D

AF Nikkor 50mm f/1.8D

AF Micro-Nikkor 60mm f/2.8D + close-up attachment lens no. 5T

AF Micro-Nikkor 105mm f/2.8D + close-up attachment lens no. 3T

AF Micro-Nikkor 200mm f/4D IF-ED + close-up attachment lens no. 6T

AF Zoom-Micro Nikkor 70–180mm f/4.5–5.6D ED + close-up attachment lens no. 6T

AF Nikkor 50mm f/1.8D + close-up attachment lens no. 1

AF Nikkor 50mm f/1.8D + close-up attachment lens no. 2

AF Micro-Nikkor 60mm f/2.8D + auto extension ring PN-11

AF Micro-Nikkor 60mm f/2.8D + auto extension rings PK-11A/12/13

AF Micro-Nikkor 105mm f/2.8D + auto extension ring PN-11

AF Micro-Nikkor 200mm f/4D IF-ED + auto extension rings PK-11A/12/13

AF Zoom-Micro Nikkor 70–180mm f/4.5–5.6D ED + auto extension rings PK-11A/12/13

PC Micro-Nikkor 85mm f/2.8D + auto extension rings PK-11A/12/13

PC Micro-Nikkor 85mm f/2.8D + auto extension rings PN-11

AF Nikkor 50mm f/1.8D + auto extension rings PK-11A/12/13

AF Nikkor 50mm f/1.8D + macro adapter ring BR-2A

AF Micro-Nikkor 60mm f/2.8D + bellows PB-6

AF Micro-Nikkor 105mm f/2.8D + bellows PB-6

AF Zoom-Micro Nikkor 70–180mm f/4.5–5.6D ED + bellows PB-6

PC Micro-Nikkor 85mm f/2.8D + bellows PB-6

AF Nikkor 50mm f/1.8D (normal) + bellows PB-6

AF Nikkor 50mm f/1.8D (reverse) + bellows PB-6

AF Nikkor 50mm f/1.8D (normal) + bellows PB-6 + extension bellows PB-6E

AF Nikkor 50mm f/1.8D (reverse) + bellows PB-6 + extension bellows PB-6E

AF Nikkor 20mm f/2.8D (reverse) + bellows PB-6 + Macro Adapter Ring BR-5

House spider
This 1:1 macro shot of a spider that had taken up residence on an old plaster wall required the 60mm Micro Nikkor lens to be almost touching the spider. The best method of focusing in this situation is to rock the camera forwards and backwards. (Carefully! You don't want to create a microscope slide specimen.) Depth of field is obviously limited.

Auto extension rings PK/PN

Extension rings are useful tools in close-up photography, providing superior quality to attachment lenses and more convenience than bellows. Rings fit between the lens and the camera body, so extending the lens from the lens mount – further magnifying the image. They usually come in sets of different sizes and can be used in isolation or in combination with each other, depending on the RR required.

TTL metering is maintained in manual or aperture-priority-auto exposure modes, though autofocus is lost.

Close-up attachment lenses

Close-up attachment lenses screw onto the front of your normal lenses, just like a filter. They are an inexpensive and convenient way to get into close-up photography, although the quality of the final image will be compromised by their use to some degree.

Seven attachment lenses are available numbered 0–6T. Numbers 0, 1 and 2 are for use with lenses up to 55mm focal length. Numbers 3–6T are two-element achromats for use with telephoto lenses. As a general guide, the higher the number of the attachment lens the closer you can focus.

Lenses

Nikon produce five micro lenses for close-up work. Three of these are discussed in detail on pages 152–154. In addition to the 60mm, 105mm and PC 85mm lenses covered there, an AF micro Nikkor 200mm f/4D IF-ED and an AF zoom-micro Nikkor 70–180mm f/4–5.6D ED lenses are also available. All five lenses are designed specifically for using in close-up photography.

AF zoom-micro Nikkor 70–180mm f/4–5.6D ED

AF micro Nikkor 200mm f/4D IF-ED

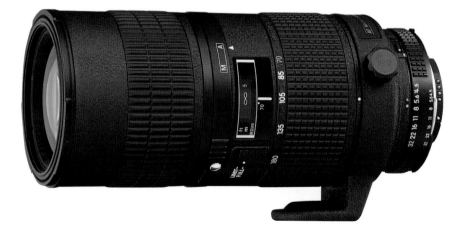

Bellows focusing attachment PB-6

For anyone serious about close-up photography, bellows provide the greatest degree of control over the RR. Like extension rings, the bellows fit between the lens and the camera body, so extending the lens from the lens mount. Unlike extension tubes, however, you can control the exact amount of extension by adjusting the position of the bellows along the rail (extension range is 48–208mm). In

Note
An auto extension ring is required when used with the F80 / N80.

combination with other accessories, bellows can gain a RR of up to 11x. TTL exposure, including auto flash exposure, is maintained in manual or aperture-priority-auto exposure modes.

Chapter **6**

Useful lenses

To my mind the lens is the most important part of any camera. I would rather attach a high-quality lens to an inexpensive camera body than vice versa. It is the lens, more than any other single factor in photography, that affects the quality of the final image.

The F80 / N80 uses the famous Nikon F-mount for attaching lenses. In theory, this means the F80 / N80 can be used with any Nikon lens made since 1959. There are, however, some exceptions to this rule and some lenses may need special alterations before they can be used with the F80 / N80, while some will simply not allow you to use the TTL meter in the F80 / N80 at all, let alone the focusing. It would be easy to criticize Nikon for this, but how many 21st century computers are compatible with 1959 computer peripherals?

Nikon has one of the most extensive lens systems of any camera manufacturer. What I have attempted to do in this book is to explain some of the main characteristics of the modern Nikon lens and identify some of the most useful lenses available for the F80 / N80; ones that you are likely to use outside of the most specialized areas of photography.

Modern lens technology

Lens manufacturers use all kinds of technology to improve the quality of their lenses. Described below are some of the main optical features that Nikon now incorporates when designing Nikkor lenses.

ED – Extra-low dispersion glass	ED glass minimizes chromatic aberration, a type of image and colour dispersion that occurs when light rays of varying length pass through optical glass. **Main benefit** Improves sharpness and colour correction.
SIC – Super-integrated coating	Especially effective in lenses with a high number of elements, SIC is a multi-layer coating that minimizes reflection in the wider wavelength range. **Main benefit** Reduces ghost flare to a negligible level.
ASP – Aspherical lens elements	ASP lenses act to eliminate some of the problem of coma and other types of aberration. **Main benefit** Particularly useful for correcting distortion in wideangle lenses, even at large apertures.
CRC – Close-range correction system	CRC lenses use a 'floating element' design that allows each lens element to move independently to achieve focus. **Main benefit** Improves picture quality at close-focusing distances and increases the focus range in wideangle, fisheye, micro and some medium telephoto lenses.

IF – Internal focusing	Internal focusing allows a lens to focus without changing its size. All internal optical movement is within the lens barrel, which is non-extending. **Main benefit** Produces a lens that is more compact and lightweight in construction, particularly in long telephoto lenses. Also makes filter use, particularly polarizers, much easier.
RF – Rear focusing	With rear focusing lenses, all the lens elements are divided into specific groups with only the rear lens group moving to attain focus. **Main benefit** Provides for quicker and smoother autofocus operation.
DC – Defocus-image control	Defocus-image control lenses are specialist lenses, which are particularly useful to the portrait photographer. DC technology allows the photographer to control the degree of spherical aberration in the foreground or background via a rotating ring. **Main benefit** An out-of-focus blur can be created that is ideal for portraiture.

D – Distance information	D-type and the new G-type Nikon lenses relay subject-to-camera distance information to the F80 / N80 for use with 3D matrix metering exposure calculations. **Main benefit** Improves the accuracy of TTL exposure readings.
SWM – Silent wave motor	Nikon's silent wave technology is used in telephoto lenses and converts 'travelling waves' into rotational energy to focus. **Main benefit** This enables accurate and quiet autofocus at high speed.
M/A – Manual/auto mode	Manual/auto mode allows almost instant switching from autofocus to manual operation, regardless of AF mode in use. **Main benefit** Reduces time lag when switching between auto- and manual focus modes.

VR – Vibration reduction	Vibration reduction lenses use internal sensors that detect camera shake and motors that automatically adjust the lens elements to minimize blur. **Main benefit** This technology reduces the occurrence of blur in images caused by camera shake, and allows hand-holding of the camera at shutter speeds slower than with a conventional lens.*
AIS – (aperture indexing shutter) meter coupling	Nikon introduced AIS lenses in 1982. This new technology allowed the camera body to determine the aperture of the lens as well as its focal length. In so doing, it made possible the introduction of programmed-auto and shutter-priority-auto exposure modes.
	* Nikon advertises that this can be up to three stops slower than a conventional lens. The rule of thumb (not that I ever believe it) is that you can hand-hold a lens at shutter speeds equal to the lens' focal length (e.g. to hand-hold a 200mm lens you must have a shutter speed of a minimum 1/200sec). Using VR technology this shutter speed could be reduced to 1/25sec. While this may be accurate in the test labs, I have used the 80-400 VR lens extensively in the field and I would trust it to a maximum of two stops difference. Even then I still prefer to support it using a beanbag or tripod.

Focal length and angle of view

How the subject is reproduced in the final image depends on the focal length and angle of view of the lens used. Lenses with a short (small) focal length have a wide angle of view, while those with a long focal length have a narrow angle of view.

Below and over the page: The following series of images shows how image magnification, perspective (see page 141) and angle of view are affected by different focal lengths and the position of the camera in relation to the subject.

Picture angle
Picture angle is dictated by the angle of view of the lens in use – the shorter the focal length the wider the area of view. A longer focal length will narrow the area of view and produce a larger image size. This dramatically affects the way your camera interprets the scene you are photographing. For reference, a 50mm standard lens has an angle of view very similar to that of the human eye.

17mm lens

20mm lens

28mm lens

35mm lens

50mm lens

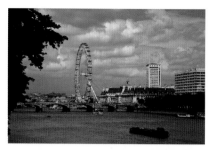

80mm lens

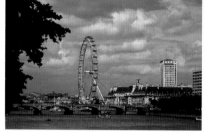

105mm lens

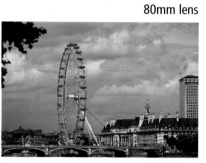

135mm lens

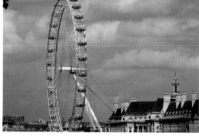

200mm lens

300mm lens

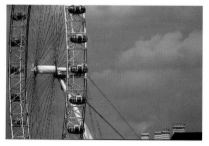

400mm lens

600mm lens

Perspective

Perspective is determined by the camera-to-subject distance and relates to the size and depth of subjects within the image space. Look at the series of images below and you will notice that, although the size of the principal subject remains the same in each picture, its relationship to the surrounding area varies considerably, depending on the focal length used. With a wideangle lens more of the foreground and background are included and a greater sense of depth is created in the image. However, with a telephoto lens the background and foreground are foreshortened. The extent of this effect depends on the focal length of the lens.

Below: The size of the hay bale varies very little as the focal length and shooting distance are changed. The size of the background objects is massively affected.

28mm lens

50mm lens

100mm lens

200mm lens

UNEAU, ALASKA, USA
he use of a 20mm lens close to the ground emphasizes the size of the stones while

Wideangle lenses

Wideangle lenses are ideal for isolating the subject, while relating it to its environment. By increasing spatial relationships they also help to create depth in an image, which, coupled with their large depth of field, makes them a favourite for landscape photographers.

AF NIKKOR 20MM f/2.8D

Optical features	CRC, D, SIC
Angle of view	94 degrees
Minimum focus distance	0.25m
Aperture range	f/2.8–f/22
Filter size	62mm
Lens hood	HB-4
Dimensions	69 x 42.5mm
Weight	270g

AF NIKKOR 24MM f/2.8D

Optical features	CRC, D, SIC
Angle of view	84 degrees
Minimum focus distance	0.3m
Aperture range	f/2.8–f/22
Filter size	52mm
Lens hood	HN-1
Dimensions	64.5 x 46mm
Weight	270g

AF NIKKOR 28MM f/2.8D

Optical features D, SIC

Angle of view 74 degrees

Minimum focus distance 0.25m

Aperture range f/2.8–f/22

Filter size 52mm

Lens hood HN-2

Dimensions 64.5 x 43.5mm

Weight 205g

AF NIKKOR 35MM f/2D

Optical features D, SIC

Angle of view 62 degrees

Minimum focus distance 0.25m

Aperture range f/2–f/22

Filter size 52mm

Lens hood HN-3

Dimensions 64.5 x 43.5mm

Weight 205g

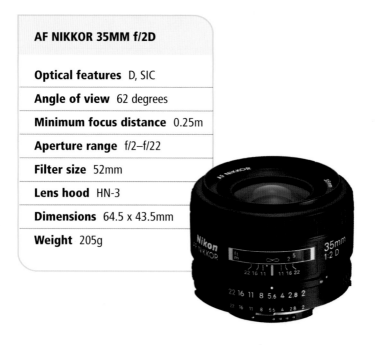

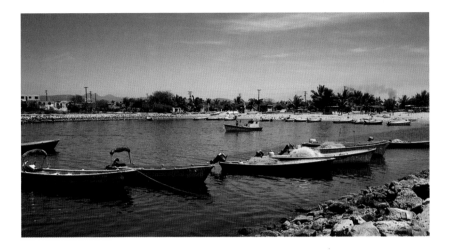

Standard lenses

In the 'old days' when you bought a new camera they always came supplied with a 50mm lens – also known as a standard lens. The 50mm lens became standard issue because it equated roughly to the view of the human eye. This characteristic, however, also became its main downfall, as photographers sought to experiment with less common perspectives.

Even so, the standard lens is an excellent starting point for anyone entering the field of photography, and understanding how to get the most from the 50mm lens will teach you a lot about the relationship between the lens and the final image as it appears on the film.

AF NIKKOR 50MM f/1.8D

Optical features D, SIC

Angle of view 46 degrees

Minimum focus distance 0.45m

Aperture range f/1.8–f/22

Filter size 52mm

Lens hood HR-2

Dimensions 63.5 x 39mm

Weight 155g

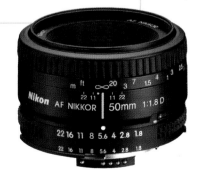

Short and medium telephoto lenses

Telephoto lenses in this range are ideal for isolating the subject. With a narrow angle of view and a small depth of field they are excellent lenses for, among other things, portrait photography, whether that be of animals or people.

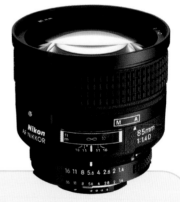

AF NIKKOR 85MM f/1.4D IF

Optical features RF, D, SIC, IF	**Angle of view** 28 degrees
Minimum focus distance 0.85m	**Aperture range** f/1.4–f/16
Filter size 77mm	**Lens hood** HN-31
Dimensions 80 x 72.5mm	**Weight** 550g

AF NIKKOR 85MM f/1.8D

Optical features RF, D, SIC

Angle of view 28 degrees

Minimum focus distance 0.9m

Aperture range f/1.8–f/16

Filter size 62mm

Lens hood HN-23

Dimensions 71.5 x 58.5mm

Weight 380g

AF DC-NIKKOR 105MM f/2D

Optical features FR, DC, D, SIC

Angle of view 23 degrees

Minimum focus distance 0.9m

Aperture range f/2–f/16

Filter size 72mm

Lens hood Built-in

Dimensions 79 x 111mm

Weight 640g

AF NIKKOR 135MM f/2D DC

Optical features RF, DC, D, SIC

Angle of view 18 degrees

Minimum focus distance 1.1m

Aperture range f/2–f/16

Filter size 72mm

Lens hood Built-in

Dimensions 79 x 120mm

Weight 815g

AF NIKKOR 180MM f/2.8D IF-ED

Optical features ED, IF, D, SIC

Angle of view 13 degrees

Minimum focus distance 1.5m

Aperture range f/2.8–f/22

Filter size 72mm

Lens hood Built-in

Dimensions 78.5 x 144mm

Weight 760g

Zoom lenses

Zoom lenses provide the photographer with great versatility and flexibility. They are economical – obviating the need to purchase several prime lenses – and can be a godsend for travelling photographers. Early zooms had a poor reputation but, while the best prime lens will still deliver greater quality than the best zoom lens, advances in technology and optical design have produced some outstanding lenses in the zoom range. In the field, zoom lenses allow you complete control of image composition in a way prime lenses find difficult to match.

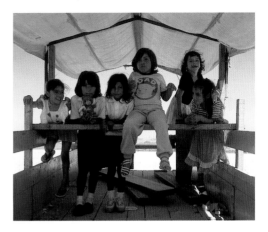

AF-S ZOOM NIKKOR 17–35MM f/2.8 IF-ED

Optical features ED, ASP, IF, D, SWM, M/A, SIC

Angle of view 104–62 degrees

Minimum focus distance 0.28m

Aperture range f/2.8–f/22

Filter size 77mm

Lens hood HB-23

Dimensions 82.5 x 106mm

Weight 745g

AF ZOOM-NIKKOR 24–120MM f/3.5–5.6 G

Optical features ASP, IF, D, SIC

Angle of view 84–20 degrees

Minimum focus distance 0.5m

Aperture range f3.5–5.6 – f/22

Filter size 72mm

Lens hood HB-11

Dimensions 79 x 80mm

Weight 550g

AF ZOOM-NIKKOR 28–70MM f/2.8 IF-ED

Optical features ED, ASP, IF, D, SWM, M/A, SIC

Angle of view 74–34 degrees

Minimum focus distance 0.7m

Aperture range f/2.8–f/22

Filter size 77mm

Lens hood HB-19

Dimensions 127 x 89mm

Weight 890g

AF-S VR ZOOM-NIKKOR 70–200MM f/2.8G* IF-ED

Optical features ED, IF, D, SWM, M/A, SIC, VR

Angle of view 34–12 degrees	**Minimum focus distance** 1.5m
Aperture range f/2.8–f/22	**Filter size** 77mm
Lens hood HB-29	**Dimensions** 87 X 215mm
Weight 1470g	

*G-type Nikkor lenses have no aperture ring and aperture should be selected via the F80 / N80's sub-command dial.

AF VR ZOOM-NIKKOR 80–400MM f/4.5–5.6D ED

Optical features ED, D, SIC, VR	**Angle of view** 30–6 degrees
Minimum focus distance 2.3m	**Aperture range** f/4.5–5.6 – f/32
Filter size 77mm	
Lens hood HB-24	
Dimensions 91 x 171mm	
Weight 1340g	

Specialist lenses

For certain disciplines special lenses are required. The F80 / N80 has the back-up of a hugely diverse lens system. I have concentrated on those lenses that you may have a call to use in some of the more popular areas of specialist photography.

Macro lenses

For a lens to be a true macro lens it should be able to achieve a reproduction ratio of 1:1 or greater (in other words the subject appears at least as big on the negative or slide as it is in real life). Because conventional lenses begin to lose their powers of resolution at these degrees of magnification – owing to the differing angle at which light enters the lens – macro lenses have been designed to deal with the problems of close-up photography.

AF MICRO-NIKKOR 60MM f/2.8D

Optical features	CRC, D, SIC
Angle of view	39 degrees
Minimum focus distance	0.219m
Working distance	90.4mm
Aperture range	f/2.8–f/32
Filter size	62mm
Lens hood	HN-22
Dimensions	70 x 74.5mm
Weight	440g
Reproduction ratio	1:1

AF MICRO-NIKKOR 105MM f/2.8D

Optical features CRC, D, SIC

Angle of view 23 degrees

Minimum focus distance 0.314m

Working distance 136mm	**Aperture range** f/2.8–f/32
Filter size 52mm	**Lens hood** HS-7
Dimensions 75 x 104.5mm	**Weight** 560g

PINK FLOWER
Depth of field is limited at close focusing distances, but you
can enhance this effect by using the lens' maximum
aperture to throw the background even more out of focus.
This is actually often essential with blossom shots or small
flower photography where the stems or twigs will intrude
quite severely unless defocused.

Super-telephoto lenses

When it's impossible to get close to the subject, such as in sports or wildlife photography, super-telephoto lenses provide extremely narrow angles of view with great image magnification, which allow you to create frame-filling images of small or distant subjects.

The sheer size of these lenses means that hand-holding is a near impossibility, with every slight movement being magnified in the final image. With lenses of this size and weight, a tripod or other form of camera support becomes an essential accessory.

Photo by Chris Weston

AF-S NIKKOR 300MM f/2.8D IF-ED II

Optical features ED, IF, D, SWM, M/A, SIC	**Dimensions** 124 x 268.5mm
Minimum focus distance 2.3m	**Angle of view** 8 degrees
Filter size 52mm internal	**Aperture range** f/2.8–f/22
Lens hood HK-26	
Weight 3100g	

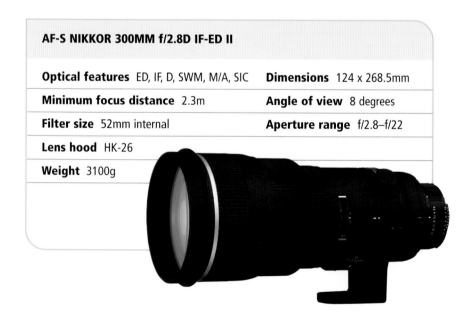

AF-S NIKKOR 500MM f/4D IF-ED II

Optical features ED, IF, D, SWM, M/A, SIC

Angle of view 5 degrees

Minimum focus distance 4.6m

Working distance 90.4mm

Aperture range f/4–f/22

Filter size 52mm internal

Lens hood HK-24

Dimensions 139.5 x 394mm

Weight 3800g

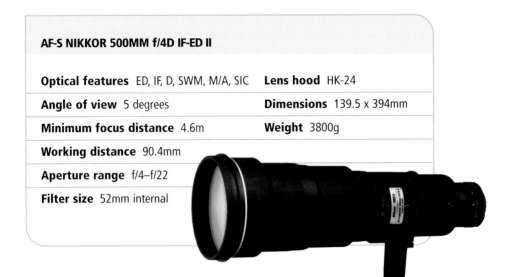

Tilt and shift lenses

These are very specialist lenses that allow you to manipulate image perspective, distortion and focus. They are particularly useful for product advertising and architectural photographers, as well as for use in extreme close-up photography.

PC MICRO-NIKKOR 85MM f/2.8D

Optical features CRC, D, SIC

Angle of view 28 degrees

Minimum focus distance 0.39m

Shift +/– 12.4mm

Aperture range f/2.8–f/45

Filter size 77mm

Dimensions 83.5 x 109.5mm

Reproduction ratio 1:2

Tilt +/– 8.3 degrees

Lens hood HB-22

Weight 770g

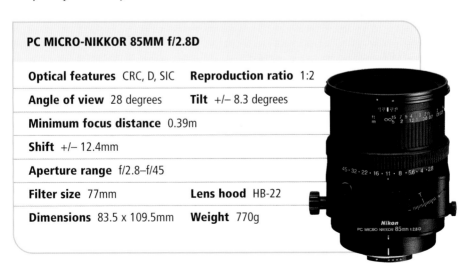

Teleconverters

Teleconverters are an inexpensive way of increasing the focal length of your lenses. Nikon teleconverters come in two versions: 1.4x, which increases the focal length by 40% (a 200mm lens becomes a 280mm), and 2x, which doubles the focal length (a 200mm becomes 400mm).

The downside to teleconverters is a slight loss in image quality and light loss. A 2x teleconverter on an f/5.6 lens will turn it into an f/11 lens. With a 1.4x there is a one-stop loss of light.

With the 2x teleconverter, lenses with a maximum aperture of f/4 or slower cannot use autofocus. With the 1.4x teleconverter and lenses with a maximum aperture of f/5.6 or slower, autofocus is disabled.

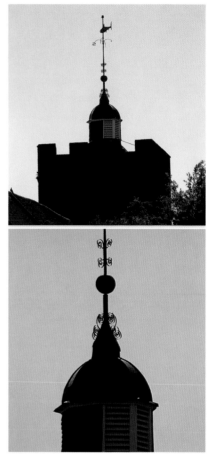

Top: 200mm lens on its own.
Above: 200mm lens + 2x teleconverter.

Tip
Teleconverters are incompatible with some Nikkor lenses. Always read the lens instruction booklet prior to attaching a teleconverter.

Lens hoods

In certain areas of photography, particularly outdoor photography of subjects such as landscapes, the lens hood is an indispensable piece of kit. The purpose of the lens hood is to protect against light scatter in the lens barrel, which shows in the final image as flare. Telephoto lenses are particularly prone to this phenomenon.

Tip
When using a lens hood on a wideangle lens check to ensure no vignetting occurs at the corners of the image.

Below: Loss of contrast is caused by light scatter in the lens barrel.

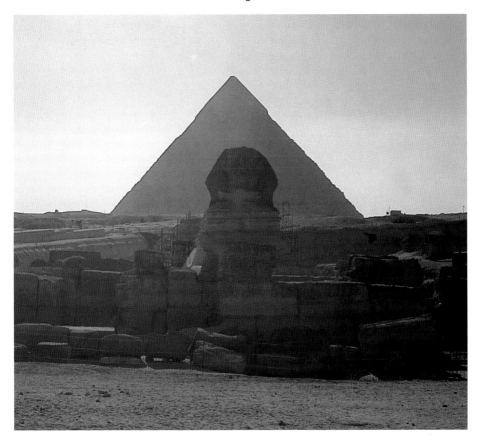

Chapter **7**

Accessories

Anyone who has caught the photographic bug will know that once the basic skills of photography are honed the desire to push your creative boundaries becomes inevitable. By choosing the Nikon F80 / N80, you have entered a gateway to one of the world's greatest camera systems. Nikon is dedicated to helping its users take the best photographs they can, and every Nikon camera is backed up by a comprehensive set of accessories, to help to achieve your goals.

Nikon accessories

The complete Nikon system is vast and it would not be physically possible to cover all the available accessories in this book. Third-party manufacturers can provide an even wider array of gadgets and gizmos. This chapter describes some of the more commonly used accessories and provides some pointers on their possible use in the field.

Filters

We have already seen how the addition of lenses and separate flash can dramatically enhance your photos, and these are generally at the top of most people's lists when it comes to increasing their system.

The third most popular accessory is probably the filter. Nikon has a full range of filters, optimized for use with Nikon lenses, and available in a range of sizes. They are divided into three fittings to match different lenses: screw in (the most common), drop in and rear interchange.

Skylight filters

The first filter on most people's list is either the skylight or UV filter, primarily used as added protection for the lens front element. They have the added benefit of removing the ultra violet radiation that film will record as a blue tint or haze in pictures taken at high altitude or near the sea. If you intend to do much landscape photography, these filters are invaluable.

Note

While polarizing filters cut out reflection on glass and water, they do not work at all when the subject is metallic.

Polarizing filters

These are available in two forms, circular and linear. Always choose a circular polarizing filter for use with the F80 / N80, as the camera doesn't allow use of linear polarizers. These filters are useful in many ways, and I always have one handy. As well as reducing reflections on glass and water, polarizers can increase colour saturation (to make blue skies and foliage darker for example) and to can reduce haze, like a UV filter.

The way a circular polarizing filter works is by rotation on the front of the lens. Normal daylight vibrates in all directions, but when light bounces off reflective surfaces the reflected waves of light begin to vibrate in a single plane. This is polarized light. By rotating the filter we can counteract the effect of the polarization; however, there are certain rules. Polarizing filters work at different angles to the reflective surface depending on whether it is glass or water.

values within an image. A favourite trick is to use a red or orange filter to darken blue skies and emphasize clouds within an image, while foliage will often become much lighter if a green filter is used.

Soft focus filters

These are primarily aimed at portrait photographers but sometimes used for landscapes. Soft focus filters work by diffusing the light, spreading highlights and softening hard edges. Nikon has the option of two soft focus filters offering different amounts of diffusion.

These are especially useful when photographing older people as they can reduce the appearance of wrinkles and skin blemishes. Equally they can add a soft, romantic look to portraits of young people and children.

Filters for black and white

By using coloured filters with black and white film, you can greatly adjust the tonal

Similarly when using black and white panchromatic film, a red filter can significantly reduce the appearance of spots in portrait photography.

Neutral-density filters

There may be times when the aperture setting and shutter speed you want to use will give an incorrect exposure. For example, you may wish to use a slow shutter speed to blur the motion of a waterfall. With an exposure of two seconds and your aperture set to a maximum of f/16, the light may be too strong and your photograph will be overexposed. This is where neutral-density filters become very useful. Neutral-density filters effectively reduce the amount of light entering the lens, similar to reducing the aperture. This means that you will be able to blur that waterfall without the final result being overexposed. Nikon's neutral-density filters cover a range of between one and four stops, denoted by ND-1, ND-2, ND-3 and ND-4.

Other accessories

There is a range of other useful dedicated accessories available for the F80 / N80.

Cable release AR-3
The cable release attaches to the screw-in socket of the shutter release button. When the camera is mounted on a tripod, camera shake can be reduced during long exposures, especially in 'Bulb' mode.

Eyepiece correction lenses
These allow short- or long-sighted photographers to adjust the dioptre of the eyepiece beyond that of the built-in adjustment control. Nine optical correction lenses are available, which, when combined with the adjustment control on the camera, provide viewfinder dioptre settings of –5 to +3DP.

Battery pack MB-16
You can add more fire-power to the camera, by attaching the battery pack to the camera, via the tripod socket. The MB-16 accepts four 1.5V LR6 (AA-size alkaline), 1.5V FR6 (AA-size lithium), 1.2V KR-AA (AA-size NiCd) or 1.2V AA-size Ni-MH batteries. It will increase the number of shots per battery set, and offers a more consistent performance even at lower temperatures.

Eyepiece magnifier DG-2
Critical focusing in areas such as macro photography can be aided by the 2x magnification of the viewfinder's central area provided by the eyepiece magnifier.

Chapter **8**

Caring for your **F80 / N80**

The F80 / N80 is a fairly robust camera that will withstand some punishment. It is, after all, a semi-professional's camera. Even so, it is a piece of hi-tech precision engineering and electronics and how you care for it will undoubtedly affect its life expectancy.

Do's and don'ts

Firstly, there are some basic rules that will help ensure your F80 / N80 does not malfunction. The shutter curtain and all electrical contacts are particularly vulnerable and you should avoid touching them at all times.

Dust should be removed regularly from the reflex-mirror, focusing screen and lens surface, using a blower brush instead of a cloth or, worse still (honest, I've seen it done) your finger.

Keep the camera in a cool environment, shading it from excessive heat and prolonged periods of direct sunlight.

I once read a letter from a disgruntled F90X owner to a photo magazine complaining that his camera no longer worked properly after he had fished it out of the river he'd dropped it in. Well, your F80 / N80 won't work in those circumstances either, being, much like the F90X, an electrical product. The odd drop of rain it can cope with. The odd drop in the sea it takes personally.

When storing the F80 / N80, remove any batteries so they don't leak and cause the battery chamber to corrode.

Camera care in extreme environments

In a world of adventure holidays and prolonged travel to further and more exotic destinations, it is likely that your F80 / N80 may accompany you to some pretty extreme environments. If treated well there is no reason why the F80 / N80 will not survive trips to even some of the most inhospitable climates. There are certain rules that need to be followed if you want your camera to come home intact.

Jungles and high-humidity environments

When using the F80 / N80 in high-humidity environments it is going to get wet. To dry the camera and lenses, place them in an airtight container with plenty of silica gel. The gel will soak up the moisture. When the gel becomes soaked, dry it out in a pan over a fire.

African savannah and dusty environments

Africa is a dream destination for many photographers. It is also one of the dustiest environments I've had the privilege of photographing. To help keep dust out of the camera I carry a leather bag, in which I place the camera when changing lenses and film whenever possible. At the end of each day's shoot I clean the camera, lenses and filters thoroughly with a blower brush for delicate parts and an aerosol spray for the outer body.

Tropical rainforests and high-rainfall environments

Rainforests are so called for a very good reason and the electronics in the F80 / N80 react badly to a soaking. In areas of high rainfall I use a fitted plastic cover over the camera and lens barrel to shield them from the wet. I change lenses and film in a dry-bag that I carry with me.

ALASKA
t looks cold, it was cold! To keep my camera warm I kept it in a
holster case underneath my coat for the duration of the shoot. I
made sure to keep the bag away from any sweat, though.

High-arctic and extreme-cold environments

Shooting in extreme-cold conditions is less of an issue for the camera than it is for you, the cameraman. In such conditions the camera will slow down in operational speed, batteries will die quickly and the LCD panels may blank out. To ensure the camera can still operate it is wise to fit an external battery pack that is kept within the confines of your clothes and close to your body for added heat. Care should be taken when loading and unloading film as it becomes very brittle in extreme-cold environments and can simply break apart.

Note

Although the environments listed here are extreme examples, the same care equally applies to Spanish beaches or Scottish mountains. Looking after your camera ensures a long life and the F80 / N80 will last for many years.

Note

The F80 / N80 may sometimes turn itself off for no apparent reason. This is caused by static electricity or poorly loaded batteries and can be rectified by turning the camera off and on again, or by removing and reinstalling the batteries.

When all else fails

If your F80 / N80 does go wrong then, unless you're a whiz with electronic engineering, take it to an authorized Nikon dealer. Never try and repair it yourself as you may cause more damage than you fix.

Tip

When using an aerosol spray to remove dust hold the nozzle at least 30cm away from the camera and lens surface and constantly move the nozzle so the stream of air is not concentrated in a single spot.

Buying secondhand

The Nikon F80 / N80 is a relatively new camera and is still in production but there are used bargains to be found. The camera is also primarily aimed at amateur photographers who tend to look after their equipment better than pros.

Therefore most of the used cameras tend to be both reasonably new and in good condition. There are still some things worth keeping an eye out for though when purchasing a used F80 / N80.

The check list below will help to ensure that you buy a secondhand camera that will provide many years further use.

1) Check the camera's outer body. There may be signs of wear on the rubber coating, which indicates heavy use. Slight sweat marks or small marks may be acceptable, depending on your own budget and criteria – many people, especially collectors, only want mint condition models.

2) Open the door of the film chamber and check the condition of the foam seal beside the hinge and around the film window. Signs of wear or rotting could lead to light leaking into the chamber and fogging your film. Also examine the chamber door lock to make sure it fastens securely.

3) Look at the film pressure plate and metal film runners that are fixed above and below the shutter housing. Extensive sign of wear indicates that a lot of film has passed through the camera.

4) Examine the shutter for finger-marks or damage, grease or bent shutter blades may cause the shutter to stick or adversely affect exposure times.

5) Examine the lens mount and ensure it is fixed tightly and that no screws are missing.

6) Check the condition of the mirror. Finger marks, scratches or cracks show a lack of care for the camera.

7) Examine the LCD screen, make sure the screen is bright and shows no sign of damage. Test the back-light.

8) Perform some basic operations of the camera. Test the meter, preferably in conjunction with a light meter or another camera and make a note of any exposure differences. There is room for some latitude, different cameras may read a scene slightly differently, but wildly different readings should be avoided. Fire the shutter at different speeds, you should easily be able to hear the difference between 1/30sec and 1/250sec for example. Test the camera's self-timer and focus point control.

9) Finally, if possible, shoot a roll of film. Listen to the motor wind and check the frame advance rate is right (use fresh batteries if you can). Examine the pictures to ensure the camera is working correctly.

No amount of checks of an electronic camera will be foolproof; it is impossible to predict if the motor wind will break down a week after you have bought the camera, for example. However, by performing these simple checks, you can be as sure as it is possible to be that the camera you have bought will allow you to enjoy your photography for many years.

Chapter **9**

Five photo principles #1
Shutter speed and aperture

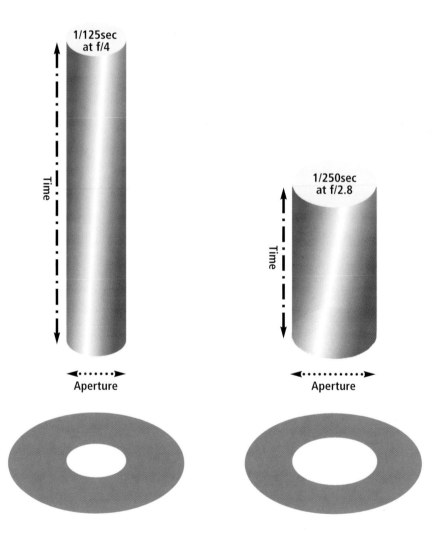

1/125sec
at f/4

Time

Aperture

1/250sec
at f/2.8

Time

Aperture

The principles of photographic exposure are simple, but often seem complicated. The amount of light that hits the film is governed by two factors: the length of time the shutter is open; and the size of the aperture the light passes through.

Shutter speeds are simple enough to understand; the longer the shutter speed, the more light gets in. This is, in fact, a linear relationship. A two-second exposure lets twice as much light through as a one-second exposure.

Apertures are more complicated as their numbering system seems more difficult to follow. The normal sequence of aperture numbers runs as follows: 1.4, 2, 2.8, 4, 5.6, 8, 11, 16, 22 and 32.

There are two things to note about aperture numbers. First, they run in a sequence which doubles every other number. If we rewrite the sequence as two sets of numbers we get 1.4, 2.8, 5.6, 11, 22 and 2, 4, 8, 16, 32. The second thing to note is that aperture numbers (or f/stops as they are also known) are not values in themselves, but divisors of the focal length of a lens. In other words, for a 50mm lens, an aperture of f/2 means a lens with an aperture of 50mm / 2 = 25mm.

But why don't apertures double with every increase? It is because the numbers represent the diameter of the opening not it's area, and it is the area that determines how much light gets through. An aperture of f/2 has twice the area of an aperture of f/2.8 and so lets twice as much light through.

Looking at the diagram shown on these pages there are three exposure combinations of aperture and shutter speed that all actually let the same amount of light hit the film. and therefore give the same exposure. If all this passes you by, don't worry. With the F80 / N80, a click on the wheel when changing the shutter speed effects the same change as a click on the wheel when changing aperture.

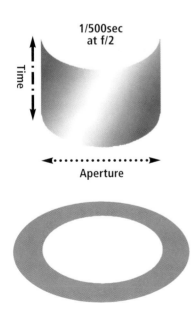

1/500sec at f/2

Time

Aperture

Five photo principles #2
Focusing and depth of field

Depth of field is one of the most argued-about concepts in the world of photography. Many folk spend hours making up depth of field tables so they can precisely determine how much will be sharp when they take a picture. The funny thing is, though, depth of field, although it can be calculated, is based on an arbitrary constant.

First it is important to decide what is meant by depth of field. One definition of depth of field is 'the amount of detail in front of and behind the point of focus that is acceptably sharp'.

As you can see, it's not the most scientific definition as it relies on a definition of what 'acceptably sharp' is. This definition is usually taken as the amount of detail that is acceptably sharp (i.e. that cannot be distinguished from the actually sharp) in a 10 by 8 inch print viewed at about 12 inches.

Once the value for the size of a circular blob that can no longer be distinguished from a sharp dot has been established, this size value is taken as the value for the so-called circle of confusion.

The factors other than the circle of confusion are: focal length; aperture; and focused distance.

As you can see from the three graphics these different factors have varying degrees of effect on depth of field. Whilst these can be checked by using the depth of field preview on the F80 / N80, it is instructive nonetheless to know the general effects of each of the factors.

Focal length is inversely proportional to the amount of depth of field so the bigger the focal length, the smaller the depth that will be on the final image.

Aperture number is proportional to the depth of field so the bigger the aperture number (i.e. the smaller the actual hole that light passes through) then the greater the depth of field there will be in the image.

Near Medium Far

Finally the focused distance. The further away you focus the greater (in numerical terms) the depth of field will be. Furthermore, the further the focusing distance the more depth of field lies beyond that distance in numerical terms than in front. In macro shooting, the depth of field is split evenly between the depth of field in front and the depth of field behind the focused position. Now you may be confused by the use of the phrase 'in numerical terms'. This is merely to highlight that when you look at a focusing sale on the lens, the distances don't go up in a linear fashion. The distance of focus travel between 1m and 2m is likely to be the same as that between 3m and 5m or 10m to infinity.

A quick recap. If you want little depth of field you want to have a telephoto lens at a close distance with a wide aperture. For maximum depth of field go for a wideangle lens focused far away with a narrow aperture.

Portraiture normally requires a narrow depth of field as you want to keep the eyes pin-sharp but everything else (particularly the background) wants to be rendered out of focus. So we use a medium telephoto set to a wide aperture and a shooting distance to suit the focal length in terms of cropping.

For landscapes, a wideangle lens focused some distance away with a narrow aperture will deliver the desired near-to-far focus.

28mm 50mm 135mm

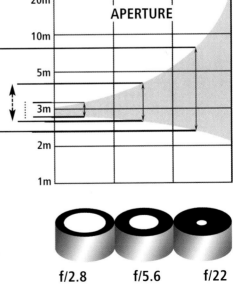

f/2.8 f/5.6 f/22

Five photo principles #3
Shutter speed and movement

When you want to stop the action in a picture, whether it is a bird in flight or a motor sports picture, you need to make sure that you use a fast enough shutter speed.

But how fast a shutter speed is fast enough? That depends on a number of factors that influence how much the subject's image is likely to move across the film frame.

The closer a subject is to the camera, the greater its movement is likely to be across the frame. Another factor is the subject's magnification owing to the focal

length of the lens in use. The longer the focal length, the greater the magnification, of the subject and its movement.

Finally there is the question of the direction that the subject is travelling in. If it is parallel to the film plane (i.e. across) then use the figures below. If it is at 45 degrees to the film plane then you can use a shutter speed one stop slower than shown below and still freeze the action. If it is directly towards or away from the camera, you can use a shutter speed two stops slower.

MINIMUM RECOMMENDED ACTION-STOPPING EXPOSURE TIMES

CAMERA-TO-SUBJECT DISTANCE (M)

28mm focal length
Subject speed (mph)

	5	10	25	50
5	1/350	1/750	1/2000	1/4000
10	1/180	1/350	1/1000	1/2000
15	1/125	1/250	1/750	1/1500
20	1/90	1/180	1/500	1/1000
30	1/60	1/125	1/350	1/750
50	1/45	1/90	1/180	1/350

50mm focal length
Subject speed (mph)

	5	10	25	50
5	1/750	1/1500	1/4000	1/8000
10	1/350	1/750	1/2000	1/4000
15	1/250	1/500	1/1500	1/3000
20	1/180	1/350	1/1000	1/2000
30	1/125	1/250	1/750	1/1500
50	1/90	1/125	1/350	1/750

135mm focal length
Subject speed (mph)

	5	10	25	50
5	1/2000	1/4000	1/10000	N/A
10	1/1000	1/2000	1/6000	1/10000
15	1/750	1/1500	1/3000	1/6000
20	1/500	1/1000	1/2000	1/4000
30	1/350	1/750	1/1500	1/3000
50	1/180	1/350	1/1000	1/2000

300mm focal length
Subject speed (mph)

	5	10	25	50
5	1/4000	1/8000	N/A	N/A
10	1/2000	1/4000	1/10000	N/A
15	1/1500	1/3000	1/6000	1/12000
20	1/1000	1/2000	1/0000	1/10000
30	1/750	1/1500	1/3000	1/6000
50	1/500	1/750	1/2000	1/4000

Keeping subjects sharp in low light

Sometimes there will not be enough light available to set fast shutter speeds. So how do you keep subjects sharp in low light?

The answer is simple. You ensure that the camera follows the subject while the shutter is open? With some subjects this will not be possible. In my experience, swallows are impossible to follow – their movement is too random to keep up. For other subjects, including other birds like jackdaws and waterfowl, it is quite simple to follow them.

Subjects that are driven or ridden also have predictable movements, and allow you to use a technique, known as panning, to freeze the main body of the subject. It is worth bearing in mind that if you pan with the subject then the background will be completely blurred. This is not a problem as, firstly, you want a clear subject against an undistracting background and, secondly, very bright or dark objects behind the subject will become blurred lines, giving an impression of motion.

How to reduce the risk of camera shake

Apart from subject movement, the one thing most likely to cause a lack of image sharpness is camera shake. Unless you mount your camera on a tripod there will always be some movement, the question is, will it effect the sharpness of the image.

The answer to that question depends on the amount of camera movement or shake, and the length that the shutter is open for. Leave a shutter open for a long time and you will get blurry hand-held pictures. But how long is too long? Well that, in turn, depends on the image magnification and so upon the focal length of the lens in use. As a general rule, you shouldn't really hand-hold a camera for longer than 1/30sec. Some people can and do hold the camera steady for much longer than that, but most of us can't. Once you start to use longer and longer focal lengths, the risk of shake goes up in proportion to the focal length, and the shutter speed should be made proportionally shorter. If this sounds complicated, it isn't. As a guide, you should choose a shutter speed of the reciprocal of the focal length of the lens in use or faster. For a 135mm lens you need a 1/135sec or faster shutter speed, for a 300mm lens 1/300sec and for a 500mm lens 1/500sec for shake-free results.

Five photo principles #4
Flash exposure

Electronic flash, whether in the form of the built-in Speedlight, an accessory flash or even a studio unit works in much the same way. An electronic pulse passes through a tube of an appropriate gas mixture and causes a brief but very bright illumination. The longest time this is likely to last is 1/500sec, but on most camera-mounted or integral flashguns it is more likely to be in the 1/1000–1/10,000sec range.

What this means is that the shutter speed you choose is never going to have an effect on the amount of light hitting the film from a flashgun. So if shutter speed has nothing to do with flash exposure calculation, then that means that, as far as the camera is concerned, aperture must be entirely responsible for controlling flash exposures. But which aperture do you need to use and how powerful is the flashgun? Luckily all flashguns come with a standardized power description known as a guide number, this is normally quoted for ISO 100 film and given in metres. Usually flash guide numbers will be quoted for ISO 100 film with metres as the measurement unit.

The guide number (GN) is an expression of the flash's power and is very useful for making flash exposure calculations.

So how does knowing a flash's GN help us? Guide numbers are expressed in a useful equation with the subject-to-flash distance and the aperture as variables.

The equation is as follows:

GN = D x N

where D is the subject distance and N is the aperture of the lens in use.

In an example with a flashgun with a guide number of 20 and a subject that is 5 metres away, by putting these figures into the equation we get the following result:

20 = 5 x N

We can rephrase this equation as:

N = 20 / 5 i.e. f/4

If the same flash were used at a subject distance of 10 metres then we would have the following:

N = 20 / 10 i.e. f/2

If the subject distance was 2.5m with the same flashgun, the aperture required for correct

exposure would be 20 / 2.5 = f/8.

But what happens if you are using a different speed film? Well, what you need to do with different speed films is calculate how many stops difference there is in the films' speeds and change the guide number accordingly. Switch to ISO 200 and the guide number changes to GN 28; use an ISO 400 film and the GN becomes 40. ISO 800 gives a GN of 56 and ISO 1600 GN 80. If this number sequence seems familiar it is, because it is the same sequential increase as apertures

(f/2, f./2.8, f/4, f/5.6, f/8). If you switch to a slower film then ISO 50 gives us a GN of 14 and ISO 25 a GN of 10.

But why do you need to do all this calculation when cameras have built-in flash meters?

Guide numbers come into their own when you have an extremely reflective subject that you are worried will fool the camera's built-in TTL flash metering into underexposing the image. They also come in handy when performing fill-in-flash calculations.

Moving the camera and the flash

Although we talk of subject distance, it is important to note that it is the distance of the flash to the subject, not the subject to the camera that matters when it comes to calculating flash exposure.

Now the majority of the time, the subject distance is the same to the camera and the flash – especially when using the camera's built-in Speedlight. However, when you are using the flash off-camera – whether with a studio flash system or an accessory Speedlight on a dedicated flash cord – it is the flash-to-subject distance that is the one to use in calculations. Why? It is more matter of

why the camera-to-subject distance doesn't matter. The further you get away from the subject, then the smaller the amount of light from a given area of the subject. However, the area on the film that the light has to illuminate is also smaller, by exactly the same proportion. In other words, the same amount of light (i.e. the flash exposure) for a given subject at two different distances is exactly the same. This is why portrait photographers in studios, once they've set up their lighting, can move the camera forwards and backwards without having constantly to recalculate their flash exposures.

Five photo principles #5
Perspective and focal length

Perspective is regulated by subject magnification, which is in turn controlled by the distance between the camera and the subject.

So why is this section about perspective and focal length? The reason is that to manipulate perspective creatively, you need to use different focal lengths, to show different aspects of subjects.

Light from the subject passes through the lens which and is focused on the film plane to form an image. Light from objects towards to the edge of the scene will travel further from subject to lens and lens to film plane than objects at the centre. With telephoto lenses, the difference between the centre and edge of the frame is tiny. But with very wideangle lenses the difference is larger, and whilst the lens succeeds in bringing everything into focus at the right place it is at the cost of correct perspective.

Perspective and architecture

From the principles of relative sizes of objects we know that the ones nearer the lens will appear bigger than the ones further away. In the case of buildings, that means that if you shoot them from the bottom, the bottom will appear bigger than the top. Now this is exactly as we see them, and while it is representative, it doesn't mean it is right. It seems to imply that the building is falling backwards. If you are in the real estate business, that is not a good look for a building you are trying to sell.

Ideally you want to shoot buildings so that the top and the bottom are in the same focusing plane. If you are shooting across a street it may be possible to stand one story up and shoot horizontally. If you are taking a picture of a very tall building, though, it will not be possible to float in mid-air to take the picture!

Luckily there are lenses designed to offer control over perspective (at least to a degree). These are known as tilt and shift lenses (see page 155), and what they do is allow you to 'square up' this effect. These PC-designated lenses are expensive though and do have limits as to how much they are able to control this effect.

This is known as perspective distortion and it is an unavoidable fact of photography.

Controlling perspective is not just about trying to make things appear as they are. Photography is often about making things appear as they are not.

To do this you need a scene with at least two elements. One that is small and near, the other that is large and far away. Shoot the scene with a distance of a few centimetres from a small subject and it appears huge compared to the far subject.

Imagine a small object and the moon. If you shoot from near to the small object with a wideangle lens then the small object will appear huge in comparison with the distant moon. Shoot from quite a long way away but with a powerful telephoto and the moon will appear huge in the sky compared with the small object.

So if you've ever wondered how nature photographers manage to get those astonishing sunsets, now you know (although you shouldn't leave a long telephoto pointing at the sun, and should never look directly through it at the sun).

Perspective and portraiture

There are two ways in which perspective and perspective distortion feature in the world of portraiture.

The first is in the group shot often taken at weddings with a wideangle lens. Those who are unfortunate to be positioned at the extreme edges of the frame will find that their heads are as much as 50 per cent wider than the lucky souls in the centre of the frame. This is a product of lens design more than a pure perspective issue, but it is better to stand a bit further away and use a longer focal length of lens to reduce the chances of this happening. That 'move back and use a longer lens' philosophy is also the best bet for individual portraits too. This is because for most people, the idea of having a big nose and a small head is not their image of perfection. Shoot from too close with a wideangle lens and that is the result you will get. If somebody already has a big nose and a small head all the more reason not to exaggerate it further!

By standing a couple of metres away and using a medium telephoto lens (say a 105mm lens) you can keep nose and head in the correct ratios. If you want to 'flatten' someone's features, double the distance from you to them and use a longer lens, for instance a 200mm lens.

Glossary

Aperture A (theoretically) circular adjustable opening of the lens which lets light into a camera. Measured in f/stops, which represent the nominal aperture's diameter expressed as a function of the focal length of the lens. The larger the f/stop number, the smaller the hole and the less light is let in. The smaller the number, the larger the hole and the more light is let in.

Auto-bracketing This function enables the F80 / N80 to take a number of pictures, at different aperture/shutter speed combinations to ensure a range of exposures.

Auto exposure lock (AE-L) A function that records and locks an exposure setting while the user recomposes the picture.

'Bulb' setting Long shutter speed mostly used at night. In 'Bulb', the shutter is open as long as the shutter release button is depressed. This means you can obtain very long exposures.

Bellows An attachment that fits between camera and lens to enable flexible close focusing. Bellows are concertina-style boxes that allow the lens to be positioned at various distances from the film.

Bracketing The same as auto-bracketing, but performed manually by the photographer.

Cable release Off-camera shutter release which allows the camera to be fired from a distance. An air release is similar but uses air rather than a metal cable to trigger the shutter release (also known as remote release).

Dateback A device that allows dates, times and shooting information to be imprinted on the film. The F80 / N80 has two dateback incarnations the F80D / N80D and the F80S / N80S.

Dedicated Indicates that a flashgun is specially designed for a particular camera range (the SB range for the Nikon F80 / N80).

Depth of field The amount of the image that is acceptably sharp. This is controlled by the aperture (f/stop) setting. The smaller the aperture, the greater the depth of field.

Depth of field preview The F80 / N80's lens is closed down to the taking aperture to show you, in the viewfinder, how much of the image is sharp before you shoot.

Diffraction The 'bending' of a light path as it passes close to a surface or edge. This causes a loss of resolution at very small apertures (e.g. f/32).

Dioptre Unit expressing the power of a lens. Expressed as positive (enlarging) or negative (reducing) when referring to eyesight correction lenses used in viewfinder eyepieces.

DX Data eXchange: barcode system and metallic contact system on a film canister that relays to the camera the film speed (ISO), exposure latitude and number of exposures of a film.

Element The main component of a lens, generally a single piece of glass with two polished and coated surfaces. A combination of elements is used to attain optimum quality.

Exposure latitude The flexibility of a film in dealing with different exposures. While most print films can perform with up to about three stops overexposure and two stops underexposure, slide film allows only about half a stop either way.

Extension tube A ring fitting between the camera and the lens to increase the distance between lens and film. This allows you to shoot subjects at a greater magnification.

Eyesight correction lens A lens that is built into or slips onto the eyepiece of a camera to make it possible for photographers to use the camera without having to wear glasses. Also known as a dioptre correction lens.

f/stop The description of the size of an aperture in relation to the focal length of a lens – f/2 in a 50mm lens would describe an aperture with a diameter of 50/2 = 25mm.

Fast lens A fast lens has a wide maximum aperture (e.g. f/2) to allow more light in and therefore allow faster shutter speeds.

Field of view The angle diagonally across the frame. Telephoto lenses have a narrow field of view, while wideangle lenses have a large field of view.

Fill-in-flash A flash combined with daylight in an exposure. Used with naturally back-lit or harshly side-lit or top-lit subjects to prevent silhouettes forming, or to add extra light to the shadow areas of a well-lit scene.

Film speed A measure of a film's sensitivity to light. Usually given as an ISO number. The larger the number, the more sensitive the film is to light (the 'faster' it is).

Filter A generic term for any object placed in front of a lens or light source that is used to modify the light falling on the subject or the film. Filters can 'correct' the colour of the light, distort certain colours, reduce reflections or allow special effects to be created.

Fisheye lens A super-wideangle lens which gives a 180 degree angle of view and a circular image.

Flare Non-image-forming light that scatters within the lens system. This can create multi-coloured circles or a general loss in contrast. It can be reduced by multiple lens coatings, low dispersion lens elements and by the use of a lens hood.

Flash guide number (GN) A number indicating the power of a flash unit. Measured in metres, the GN relates to the aperture needed to expose a certain speed film with the subject at a certain distance from the flash. GN divided by distance equals required aperture (GN/d = f). Usually measured against ISO 100 film. When using faster or slower films, the guide number doubles or halves every two stops so, for example, ISO 400 film will deliver a guide number twice as big as ISO 100 which itself is twice as big as for ISO 25.

Flash sync The sync(hronization) speed is the maximum speed at which a focal plane shutter can work with flash. At speeds faster than the sync speed, only part of the film shot with the flash will be lit.

Focal length The optical definition of focal length is irrelevant, but the effects are vital. It defines the magnification of the image and the field of view of a lens. The longer the focal length the larger the image magnification on the film.

Focusing The adjustment made to the distance between the lens and the film to get a sharp image.

Focus lock Activated by partially depressing the shutter release or by using the 'AE-L/AF-L' button to focus on an off-centre subject. It allows you to recompose while keeping the main subject in focus.

Fogging When an area of light-sensitive material has been damaged by exposure to light, multiple X-rays or chemicals. This can take the form of a misty or black negative or a bleached area on transparency film.

Hotshoe The electrical fitting on top of a camera for electronic flash units, or other accessories. It enables the flash to synchronize with the shutter.

Hyperfocal distance A useful shortcut for getting maximum front-to-back sharpness at a given aperture. When the lens is focused at infinity, the HFD is the distance of the nearest object still in focus. When the lens is then focused at the hyperfocal distance, all objects between infinity and half the hyperfocal distance will be sharp.

Incident lightmeter An exposure meter that measures the light falling on the subject, rather than the light reflected by the subject (as is the case with the F80 / N80's built-in meter patterns).

ISO Abbreviation for the International Standards Organization. A measure of nominal film sensitivity.

LCD Liquid Crystal Display. A data display panel common on cameras and accessories.

Macro lens A lens that allows close focusing and large image magnification. True macro lenses produce 1:1 images on film.

Metering A system the camera uses to read the amount of light coming from a scene. Metering systems include: spot metering, centre-weighted metering, and 3D matrix metering.

Multiple exposure Taking several exposures on a single frame of film.

Neutral density (ND) Filters that reduce the brightness of an image without affecting colour. Graduated ND filters are useful for reducing contrast between a very bright sky and darker land in landscape shots.

On-demand grid lines Viewfinder display system introduced on the F80 / N80 to show compositionally helpful pairs on intersecting lines.

O-rings Seals used in underwater, weatherproof and professional cameras to keep water and dust out of the camera.

PC Abbreviation for Power Cord. The standard camera-flash connector.

Pushing/pulling Pushing is uprating the ISO speed of the film and compensating for this by developing the film for longer than normal. Pulling is the opposite, where a film is rated at a slower speed.

Rear/second-curtain sync It is usual for a flash unit to fire as soon as the second shutter curtain is fully open. With rear-curtain sync, the flash is fired the instant before the second shutter closes.

Ring flash A circular flash unit that fits around the end of a lens. This creates a shadowless image. Ring flash is popular for macro work, but also has its uses in fashion and portraiture.

Slow sync flash A flash burst combined with a slower than usual shutter speed, i.e. a shutter speed longer than the maximum flash sync speed.

SLR Single Lens Reflex. A camera where you view the image through the same lens that projects the image onto the film.

Speed Term applied to the light sensitivity of specific films or plates. The faster the film speed, the greater the sensitivity to light and the shorter the required exposure. Film speed is now expressed in ISO numbers (it used to be ASA).

Spot meter An exposure meter that allows you to measure the intensity of reflected light from a very small or distant area.

Standard lens A standard lens is one that provides approximately the same field of view as the human eye. In 35mm format this approximates to a 50mm lens.

Stopping down The reduction of the opening of the diaphragm aperture (e.g. from f/8 to f/11) which cuts down on the light entering the lens and increases depth of field.

Sync lead A cable that connects a flash unit to the PC socket of a camera or flash meter. The camera triggers the flash, via the cable, when the shutter is open.

TTL Through-the-lens. Normally applied to metering where readings are measured through the taking lens rather than through a separate camera window.

Vignetting The cropping or darkening of the corners of an image. This can be caused by a generic lens hood or by the design of the lens itself. Most lenses do vignette, but to such a minor extent it is unnoticeable. This is more of a problem with zoom lenses than fixed focal lengths.

Wideangle Lenses with a wider angle of vision than the human eye. Lenses wider than 60 degrees are wideangle, more than 90 degrees is super-wide.

Zoom lens A lens with a variable focal length that can be altered by the photographer.

Useful information

NIKON SITES:
Nikon USA
www.nikonusa.com

Nikon UK
www.nikon.co.uk

Nikon Japan
www.nikon.co.jp

Nikon Worldwide Network
Worldwide headquarters home page for the Nikon Corporation
www.nikon.com

Nikon Imaging Corporation
European product finder
www.nikon-image.com

Nikon Electronic Imaging Products
European User Support
www.nikon-euro.com

Nikon HIstorical Society
www.nikonhs.org

Nikonians
Nikon users group
http://www.nikonians.com/

Photonet
Nikon F80 / N80 users forum
http://www.photo.net/nikon/n80

Links to Nikon-related Sites
www.nikonlinks.com

Nikon Owners' Club International
Worldwide club for Nikon users
www.nikonownersclub.com

Nikon Users Site
www.nikonusers.org

Nikon User Forum and Gallery
www.nikoninfo.org

EQUIPMENT:
Grays of Westminster - Exclusively... Nikon
Award-winning Nikon-only dealer
www.graysofwestminster.co.uk

MXV Photographic
Mail order dealers in used photographic equipment
www.mxv.co.uk

PHOTOGRAPHY:
Natural Photographic
Wildlife photography and journalism by Chris Weston
www.naturalphotographic.com

PHOTOGRAPHY PUBLICATIONS:
Black & White Photography
www.gmcmags.com

Outdoor Photography
www.gmcmags.com

Index

Acknowledgements

While it is the author's name that appears on the cover of the book and, therefore, it is he who takes the plaudits, no book would be possible without the combined efforts of the supporting team. I would like to thank everyone at PIP who helped in the production of this book, including Paul Richardson, James Beattie, Gerrie Purcell, Gilda Pacitti and Anthony Bailey. Also, to Elaine Swift and Charley Hayes at Nikon UK who gave of their time so willingly. Finally, many thanks to the gruesome twosome, you know who you are and you know what you've done!